IMAGES
*of* America

# TOLEDO

## THE 20TH CENTURY

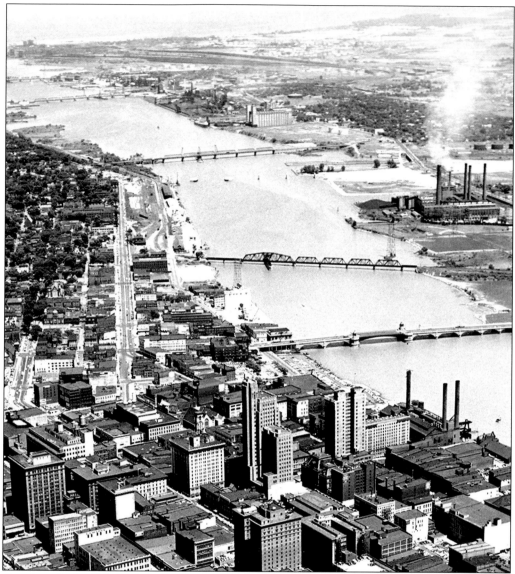

Seen here is the Toledo skyline in the 1950s.

IMAGES
*of America*

# TOLEDO

## THE 20TH CENTURY

Barbara L. Floyd

ARCADIA
PUBLISHING

Published by Arcadia Publishing
Charleston, South Carolina

Printed in the United States of America

Library of Congress Catalog Card Number: 2005928880

For all general information contact Arcadia Publishing at:
Telephone 843-853-2070
Fax 843-853-0044
E-mail sales@arcadiapublishing.com
For customer service and orders:
Toll-Free 1-888-313-2665

Visit us on the Internet at www.arcadiapublishing.com

*To Bill, who continues to teach me about 20th-century history
while I teach him about 19th-century history.*

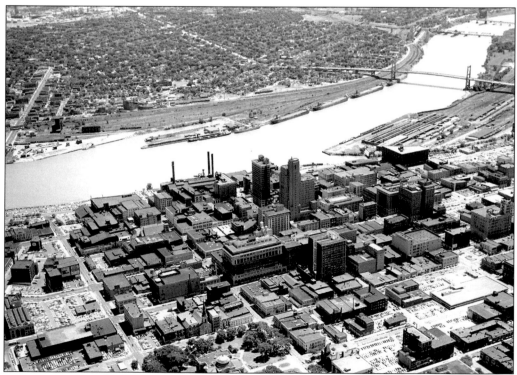

Here is the Toledo skyline, around 1950, looking south.

# CONTENTS

# ACKNOWLEDGMENTS

As with the previous volume of this series, *Toledo: The 19th Century*, I would like to thank the staff of the Ward M. Canaday Center for Special Collections at the University of Toledo for all they did to make the completion of this book possible. Kim Brownlee, Dale Ebersole, Sandy Rice, Mary Koslovsky, David Chelminski, Sara Wise, Ryan Eickholt, Casey Stark, Jim Seelye, and Shamsi Modarai kept the center together during a very busy time while I was writing. It is wonderful to work with such a dedicated and diligent group of people whom I can depend on to help without even asking.

I am grateful to Melissa Basilone at Arcadia Publishing for her understanding and, most importantly, her patience.

Most of the photographs appearing in this book are from the collections of the Ward M. Canaday Center, particularly the Donald Duhaime Photograph Collection, the Joseph M. Jackson Photograph Collection, and the University of Toledo Archives, including those by photographer Bill Hartough. Unless otherwise noted, the photographs are from the center. Others are from the collections of the Local History and Genealogy Department of the Toledo–Lucas County Public Library, and are noted in the captions as such. My thanks go to James Marshall, head of the department, Greg Miller, and Mike Lora for their assistance with the images and for granting permission to include them here. I am also grateful to Julie McMaster, archivist for the Toledo Museum of Art, who not only found some wonderful photographs for this book, but also sent them to me quickly. The photographs from the museum's collections are also noted.

Lastly, I would like to thank my husband, Bill Little, who provided the much-needed support to finish this project during a hectic time.

# INTRODUCTION

In the 19th century, Toledo was imagined to be the "Future Great City of the World." Of course, Jesup W. Scott's vision for the city never materialized, nor did that of city planner Harland Bartholomew in the 1920s, or that of Norman Bel Geddes's "Toledo Tomorrow" in the 1940s, or that of the many planners and promoters who dreamed of the Portside Festival Marketplace in the 1980s. While Toledo in the 21st century may not reflect the visions of any of these people, it is nonetheless a pleasant, progressive, and productive city that has evolved rather than reinvented itself.

The 20th century began on a high note as the city rose to national prominence as was one of the shining lights of the Progressive Movement. Led by mayors who believed that government reforms would produce a good place to live, city leaders enacted many reforms that may seem radical today—proportional representation, home rule, non-partisan elections, and eventually, in 1935, a city manager form of government. But elected officials were not alone in their daring plans. Corporate leaders also took the lead in improving the city, primary among them, Edward Drummond Libbey. His investment in an art museum created a lasting legacy that today most residents take for granted, but at which visitors to the city marvel. After years of struggle, Jesup W. Scott's idea for a university finally took root, and its new architecturally aesthetic campus, funded by Toledo taxpayers, was another symbol of a thriving city. Recreational opportunities flourished in the first decades of the 20th century as transportation improved, allowing citizens easier access to city and metropolitan parks, as well as to amusement parks on the Great Lakes. The city began to collect a menagerie of animals that served as the impetus for founding a zoo. A live theater scene brought the best of vaudeville to the city.

Economically, glass continued to be key, and the first decades of the 20th century saw many spin-off companies from Libbey's original investment, eventually resulting in four major corporations. Bicycle manufacturers evolved into automobile manufacturers, which attracted related industries like spark plug and transmission producers. By the end of the 1920s, Toledo did indeed look like it just might become the Great City.

Everything changed in 1929. The Depression hit Toledo particularly hard, with some estimates of unemployment as high as 50 percent. The demand for public relief was more than the city could supply. Bread lines, "Hoovervilles" along the river, and violent strikes characterized the area in the 1930s. Massive public investment from the federal government did much to improve the infrastructure of the city, however, and is seen as a lasting legacy of Pres. Franklin

Roosevelt's New Deal programs. The New Deal brought the Anthony Wayne Trail, numerous buildings at the Toledo Zoo, a football stadium for the university, a gleaming public library, and improvements in the city's parks. World War II also helped revive the economy of the city, particularly its automobile industry. But despite these lifelines, Toledo in the 1940s was a very different place than it had been in the 1920s. The heart of the city began to fail, and the movement away from the city center to surrounding areas continues apace today. Downtown Toledo became a place to venture for a specific reason like a baseball game or dinner, but not a place perceived as integral to everyday life, like the suburban shopping mall.

If the Depression started Toledo's decline, the 1980s accelerated it. The freewheeling capitalistic frenzy that encouraged corporate mergers devastated the industries that were the economic underpinnings of the city. In 1987, Kohlberg Kravis Roberts and Company bought Owens-Illinois and took the company private. Libbey-Owens-Ford was split into two parts, and Pilkington North America, a British company, took over the flat glass operations. Reliance Electric sold Toledo Scale to Ciba Geigy, who merged it with Mettler Instrumente AG, changing its name to Mettler Toledo and moving its headquarters to Columbus. Willys-Overland, which had been acquired by outside interests Kaiser-Frazer in 1953, went through a series of owners that included the American Motors Corporation, Renault, Chrysler, and currently DaimlerChrysler. Some long-standing Toledo companies simply vanished in the period of corporate buy-outs, like the Questor Corporation and Sheller Globe. The savings and loan scandals of the period led to the disappearance of First Federal of Toledo and a banking scandal claimed Toledo Trust. In a 1991 interview in the *Toledo Blade*, a corporate executive of Cooper Industries of Houston, Texas, which had purchased Champion Spark Plug in 1987, made this comment about the closing of the last spark-plug factory in Toledo: "We needed to consolidate to lower costs." Operation Desert Storm in 1991 was the first U.S. confrontation since World War II that did not utilize Jeeps. Today, the Fiberglas Tower, once a symbol of the importance of Toledo's glass industry, stands empty; Owens-Illinois is moving to Perrysburg; and the headquarters of Libbey-Owens-Ford no longer bears the company name.

Ironically, at the same time the economy was splintering apart, city fathers and investors were making grand plans to revitalize the downtown. But their dream, called the Portside Festival Marketplace, became the symbol of a failed vision rather than a new beginning. Opened in 1984 with great expectation, it closed in 1991, a psychological blow to the city that still lingers today.

Toledo at the start of the 21st century is not the Future Great City of the World or Toledo Tomorrow's futuristic diorama. But its struggles are hardly unique to the industrial Midwest. Perhaps its greatest asset is what Jesup Scott recognized in 1868: its geography. Railroads and canals have been replaced by the turnpike and interstates, but Toledo still lies at a geographic crossroads that will continue to shape the city's future. It is built on a Great Lake and a major river, and intersected by the longest east-west and north-south interstates in the nation. While its economy and leaders may change, Toledo's location will not. The city's future and its past are connected by it, a fact that Jesup Scott realized almost two centuries ago.

# One

# FOLLOWING THE
# GOLDEN RULE

As the 20th century began, Toledo was at the forefront of a national reform effort that became know as the Progressive Movement. It spanned the years from about 1890 to the start of World War I and was a reaction to the excesses of industrialization defining the latter half of the 19th century. One of the leaders of the movement was Samuel Jones, who was himself an industrialist and founder of Toledo's Acme Sucker Rod Company in 1893. But unlike many of his ilk, Jones cared deeply about the plight of the working class, and he carried this concern into the management of his business. The company had only one rule: the Golden Rule. He paid his workers a decent wage, trusted them to keep their own time, built a recreational park for their families, and sponsored educational and cultural opportunities for their intellectual development.

In 1899, Jones ran for mayor as an independent after the Republican party, which had dominated Toledo politics for decades, refused to nominate him. Jones campaigned on a platform of civic reform and captured 70 percent of the vote. His election ushered in a nearly 20-year period of reform in the city. The achievements of Jones and his successors included a city park system, zoological gardens, non-partisan city elections, proportional representation, home rule for cities, and reduced streetcar fares.

Jones died in office in 1904 at the age of 57, but was succeeded by another Independent party reformer, Brand Whitlock. Whitlock was re-elected three times and served as mayor until 1913, when he was appointed minister to Belgium.

In addition to good government reforms, the first two decades of the 20th century produced improvements that made Toledo a more livable city. These included the founding of the Toledo Museum of Art, the creation of new amusement parks made accessible by inter-urban transportation lines, the promotion of the women's suffrage movement, the beginnings of a strong labor movement, and the establishment of many social service agencies to assist the poor.

The period also saw the rapid expansion of many of the heavy industries that had developed in the 19th century. Building on his success at the World's Columbian Exposition in Chicago in 1893, Edward Drummond Libbey created another Libbey Glass exhibit at the 1904 St. Louis World's Fair, this one featuring a punch bowl advertised as the largest piece of cut glass ever created. The company continued to grow and began to spin off other glass companies. In 1907, Michael Owens incorporated the Owens Bottle Company to promote the success of

his automatic bottle machine. Edward Ford's plate glass company, founded in 1898 in nearby Rossford, had become the largest glass factory in the country by 1922. Other thriving companies included Toledo Scale, incorporated in 1901 with the corporate slogan "No Springs, Honest Weight," and the DeVilbiss Manufacturing Company, founded in 1905 by Dr. Allen DeVilbiss to market atomizers.

A new industry emerged from Toledo's bicycle factories and wagon works of the previous century: the automobile. By 1920, automobile production had begun to dominate industry in the city, and would continue to do so throughout the 20th century.

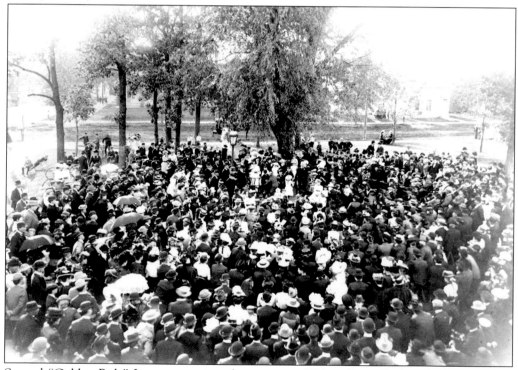

Samuel "Golden Rule" Jones campaigns for mayor in 1899 in Jones Park at Field and Segur Streets. Standing on a platform near the tree, he gestures to the crowd of supporters.

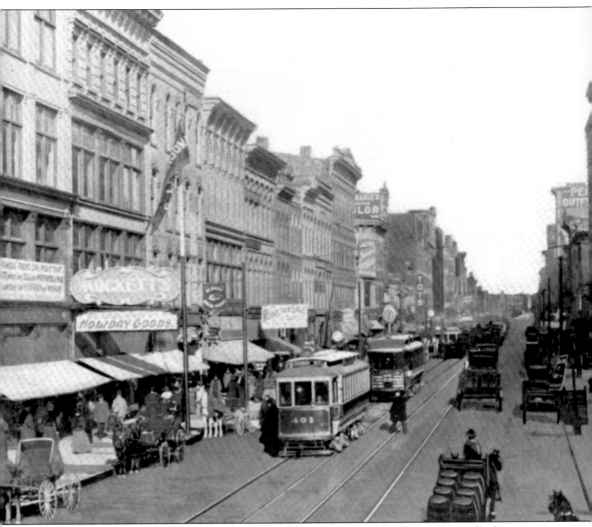

In the 1880s, the Toledo Electric Railway Company and the Toledo Electric Street Railway were created to not only provide public transportation, but also to wire the city for electricity. By 1892, all of the city's trolley lines were electrified, and horse-drawn trolleys were obsolete. Once the overhead electrical lines were strung, competing companies sprang up, creating a confusing array of lines and schedules. The Toledo Railways and Light Company (later Toledo Edison) began to consolidate the industry by buying up many smaller lines, and by 1907 had become the major streetcar provider.

In 1904, the city council granted the Toledo Railways and Light Company a 25-year franchise. The agreement raised the price of the fares from 3¢ to 5¢. Mayor Jones vetoed the franchise agreement, one of his last acts as mayor before he died in office. His successor, Brand Whitlock, attempted to negotiate a settlement to preserve the 3¢ fares, but the controversy dragged on. In 1912, a new public commission was created to oversee the streetcar company. The issue of fares did not fade, and three years later, the city council forced a shutdown of the lines rather than agree to a rate hike. (Courtesy of the Toledo–Lucas County Public Library.)

When Samuel Jones died, his Independent party nearly died with him. As his successor, the party selected Brand Whitlock, seen here, a friend and advisor to Jones. Whitlock continued to champion many of Jones's causes. In 1902, Jones's political foes had managed to pass legislation taking control of the city's police away from the mayor. The matter ended up in the Ohio Supreme Court, which declared the act unconstitutional. Backlash over the efforts to control the city led to a new Ohio Constitutional Convention in 1912, which adopted home rule, giving cities more autonomy. As a result, in 1914, Toledo voters ratified a new charter that provided for non-partisan city elections. In the elections of 1915, 1917, and 1919, candidates had no party affiliation, and no one campaigned.

Because Toledo spanned two sides of the Maumee River, bridges were a necessity. In 1908, a boat that had loosened from its moorings knocked down half of this Cherry Street Bridge, which had been built in 1884.

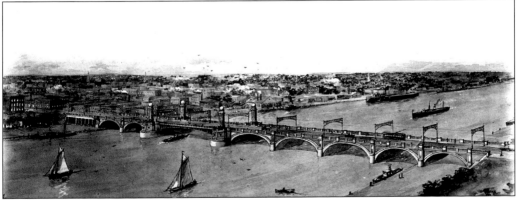

A new bridge was planned to be made of concrete. This artist's rendering shows the proposed bridge approved by the city council in 1913. Originally budgeted to cost $525,000, it actually cost nearly twice that amount.

Michael J. Owens began working for Libbey Glass founder Edward Drummond Libbey in 1888. He experimented with technological improvements in glass production, including a machine to automatically produce glass bottles, and in 1907, the Owens Bottle Company was incorporated. Here, its original board of directors, including Owens (center) and Libbey (far right), visits the company's first licensee of the new machine in Newark, Ohio.

In 1906, Irving Colburn, pictured here, incorporated the Colburn Machine Glass Company to raise capital for his new invention—a machine that would draw continuous sheets of flat glass from a bed of molten glass. A roller would pick up molten glass and form it into a uniform sheet without the imperfections common in other flat glass production methods. The sheet was then sent down a long line of conveyors, where it was allowed to cool slowly. At the end, the ribbon of glass was cut. Colburn's early machine proved more difficult to perfect than the simple concept implied. Numerous failures led his backers to withdraw support, and Colburn had to auction off his patents in 1912.

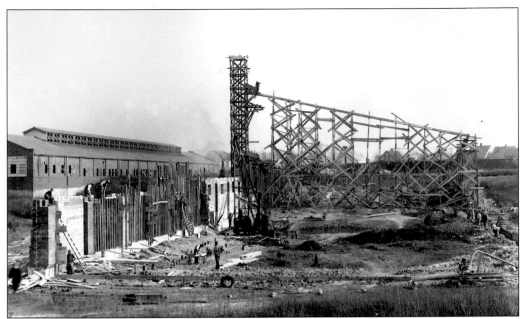

Michael Owens believed Colburn's flat glass process could work. He convinced Edward Drummond Libbey and his board of directors to purchase Colburn's patents, despite Libbey's skepticism that the machine would ever be successful. In 1912, the Toledo Glass Company began construction on a new factory on Castle Boulevard that became known as the Toledo Sheet Glass Company.

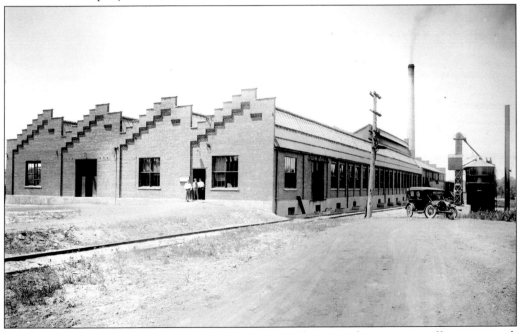

The factory was completed the following year, costing eight times what was originally anticipated. Libbey continued to doubt its success, but investors supported the company, largely because of Michael Owens's involvement. The business was incorporated in 1915 as the Libbey-Owens Sheet Glass Company.

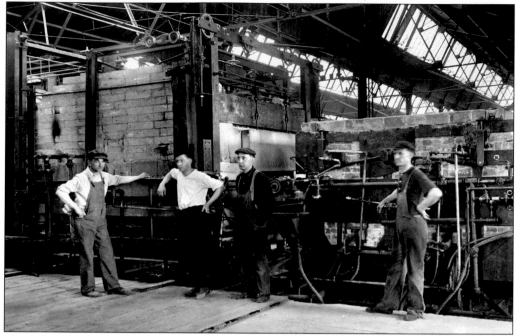

The Colburn process required a constant influx of ingredients at the beginning of the line, which were then heated to produced molten glass.

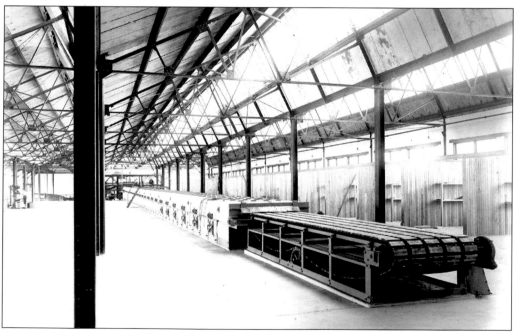

The molten glass was drawn over rollers and sent down a long conveyor. At the end, large sheets of glass were cut and sent over to the cutting room.

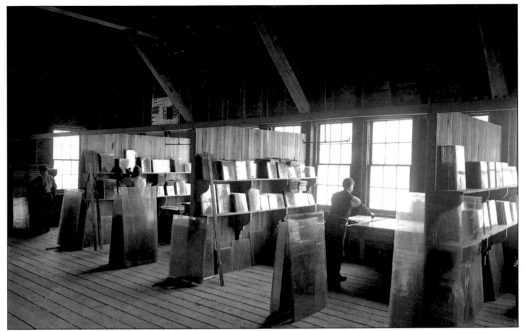

In the cutting room, the glass was cut to ordered sizes, then crated for shipment. Unfortunately, Irving Colburn did not live to see his process fully successful, as he died in 1917.

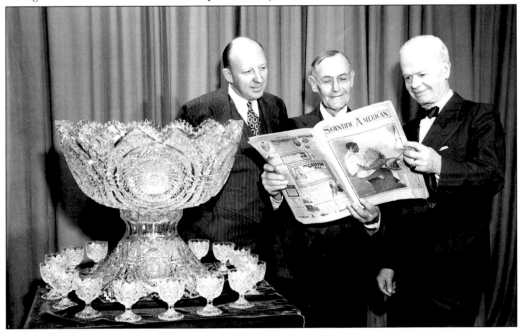

For the 1904 St. Louis World's Fair, Libbey Glass wanted an exhibition to top the success of its exhibit at the World's Columbian Exposition of 1893. To draw the crowds, the company displayed the largest piece of cut glass ever produced—a brilliant punch bowl and glasses. An issue of *Scientific American* that year featured the production of the piece on its cover. In 1946, Owens-Illinois, then owners of Libbey Glass, donated the punch bowl to the Toledo Museum of Art, as is shown in this photograph.

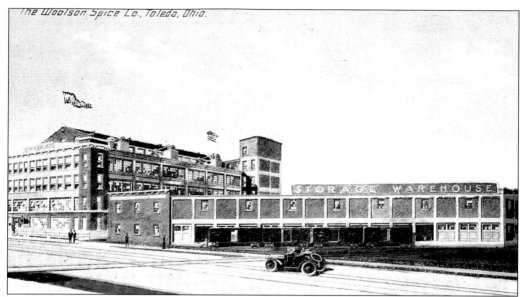

In the first decades of the 20th century, Toledo was a national leader in the coffee roasting and spice grinding business, employing over 1,000 people in 1922. The largest of these companies was the Woolson Spice Company, organized in 1882 by A. M. Woolson, John Berdan, James Secor, and others. The company moved into this building at Summit and Sandusky Streets in 1909. Its most popular product was the Lion brand of coffee.

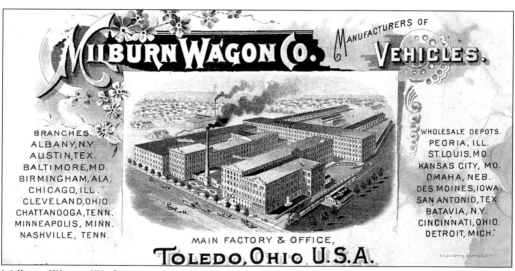

Milburn Wagon Works was one of the largest manufacturers of farm wagons in the 19th century. Its factory, located on Monroe near Auburn, was completely mechanized. However, as the demand for farm wagons dropped due to urbanization, the company went into decline.

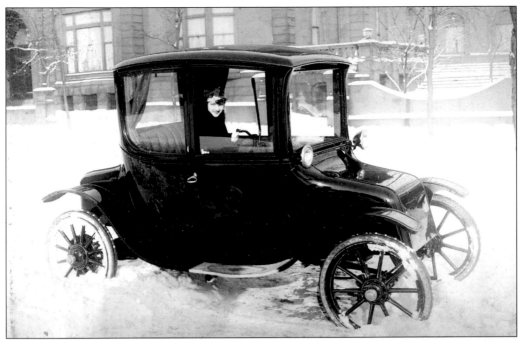

In the early years of the 20th century, Milburn Wagon Works changed its production facility to build the Milburn Electric automobile.

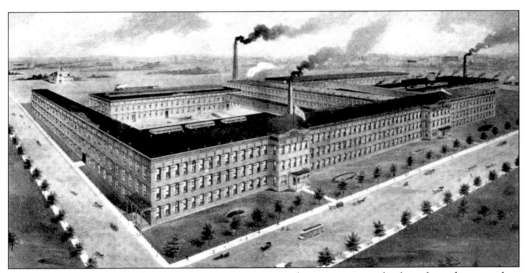

Other automobile manufacturers sprang up as natural successors to the bicycle industries that had dominated the city in the 19th century. In 1900, A. A. Pope's American Bicycle Company began to produce a steam-powered car called the Toledo. Two years later, it replaced this model with a gasoline-powered car named the Pope Toledo. The Pope Motor Company, shown here, was driven into bankruptcy in 1907 after a machinist strike forced it to make crippling concessions to the union. That year, John N. Willys's Overland Automobile Company of Indianapolis purchased the business. Willys consolidated operations of his company in Toledo in 1911.

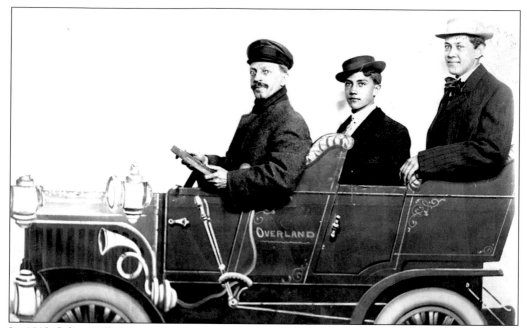

In 1913, John Willys's company began producing Willys-Knight automobiles and the popular Overland model.

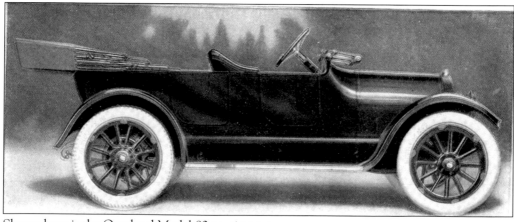

Shown here is the Overland Model 83 touring car.

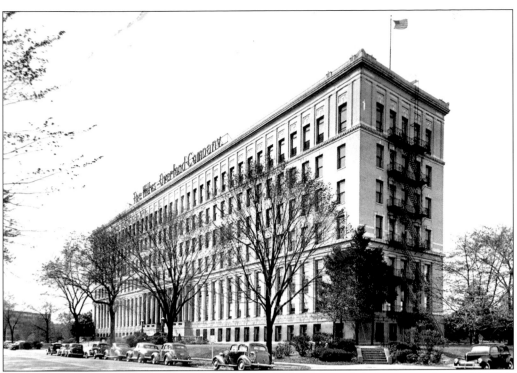

By 1918, Willys-Overland had become the second largest automobile factory in the world. This corporate headquarters building was constructed near the Toledo factory in 1914.

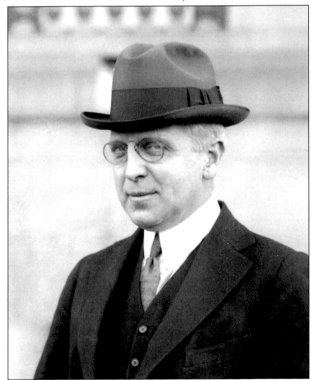

Chairman John Willys is pictured here. (Courtesy of the Toledo–Lucas County Public Library.)

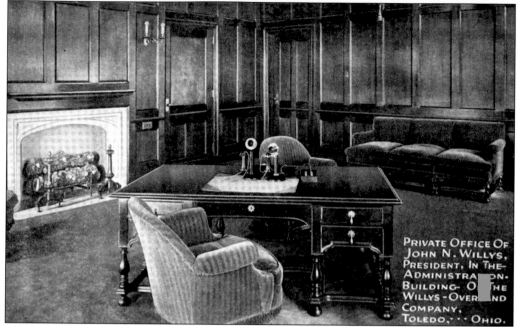

PRIVATE OFFICE OF
JOHN N. WILLYS,
PRESIDENT, IN THE
ADMINISTRATION.
BUILDING OF THE
WILLYS-OVERLAND
COMPANY,
TOLEDO, OHIO.

The headquarters building was the picture of corporate opulence and sophistication, as evidenced by John Willys's paneled private office, complete with two telephones.

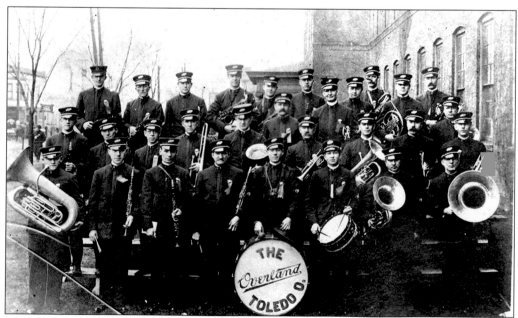

The Willys-Overland Company even had its own band.

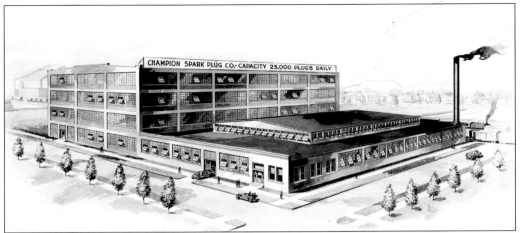

The prosperity of the Willys-Overland Company attracted many automobile suppliers to the city. The Champion Spark Plug Company moved to Toledo in 1910 and later built this factory at Avondale and Upton. (Courtesy of the Toledo–Lucas County Public Library.)

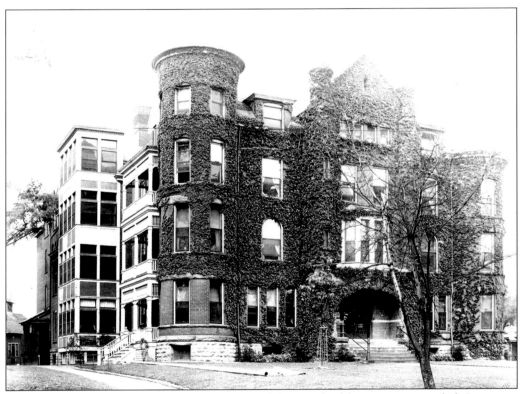

Urbanization in the early 20th century changed the way health care was provided. It was no longer feasible for doctors to treat patients in their homes. Hospitals, once viewed as a place for the poor to go to die, were soon seen as facilities for the treatment of serious illnesses. And improvements in antiseptic procedures meant going to a hospital was no longer a death sentence. Toledo Hospital was located in this building at Cherry and Sherman Streets from 1892 to 1930.

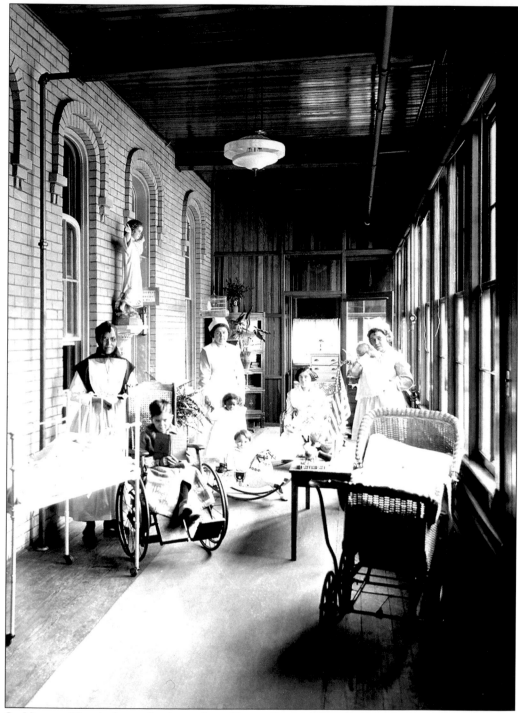

St. Vincent Hospital was also located on Cherry Street. This photograph shows the Children's Pavilion in 1915.

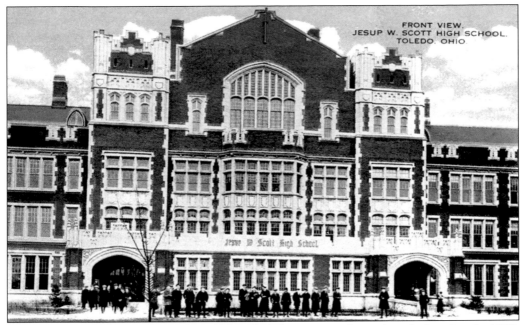

Toledo's desire to improve the quality of life included improving the quality of education. In 1908, taxpayers approved a $500,000 bond levy to construct two new high schools to replace Central High School, which had been built in 1854. The levy provided funds for Jesup W. Scott High School, opening in 1913, and Morrison R. Waite High School, opening the following year.

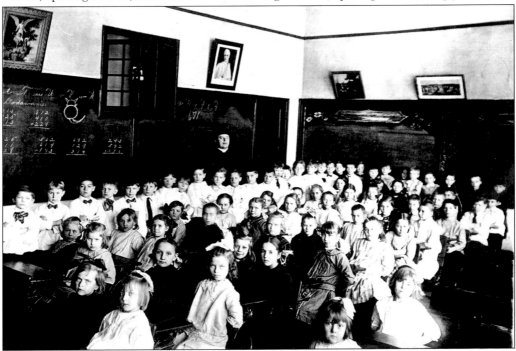

Immigrant populations arrived with deeply held religious beliefs contrary to the predominant Protestant religions. To preserve their cultural and religious ties to the Old World, Catholic immigrants started their own schools, including this unidentified school in Toledo.

Many of the Poles who immigrated to Toledo in the 1880s settled in the Lagrange Street area. St. Hedwig's, built in 1901, was the focus of the community's religious and cultural life. In the first decade of the 20th century, the Polish-born population of the city doubled to over 7,000. (Courtesy of the Toledo–Lucas County Public Library.)

A Toledo immigrant family poses for a photograph.

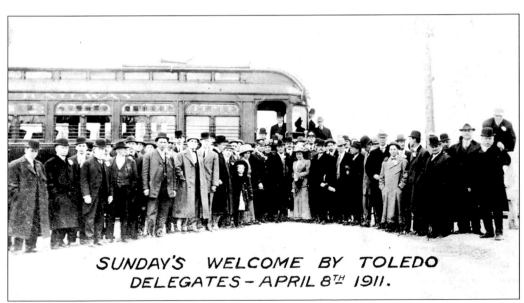

SUNDAY'S WELCOME BY TOLEDO
DELEGATES – APRIL 8TH 1911.

The Toledo Evangelistic Association and the YMCA brought evangelist Billy Sunday to the city in 1911. A temporary tabernacle was built for his revival, and Sunday offered services for seven weeks, preaching to an estimated 800,000. This image shows Sunday's welcome to the city.

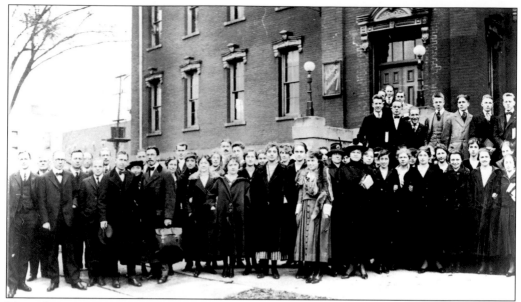

Manual training was a successful educational reform idea in the late 1800s, but its popularity started to fade at the dawn of the new century. Toledo University began steering its curriculum away from manual training and toward that of a post-secondary university. In 1904, the institution merged with the Toledo Medical College and added pharmacy to its offerings of majors. The College of Arts and Sciences (1909), College of Industrial Science (1910), College of Commerce and Business (1914), and Teachers College (1916) followed. In 1914, the fledgling university moved into an old elementary school at Eleventh and Illinois Streets downtown.

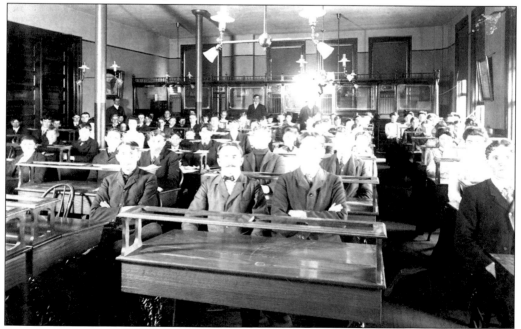

As industry and commerce became critical components of the city's economy, the men and women of Toledo needed to learn practical business skills. Seen here is a class at Davis Business College, located at Tenth and Adams Streets downtown.

The Progressive Era reforms included not just government and education, but also culture. The industrialists who had made their fortunes in the 19th century felt the need to give back to the city. Edward Drummond Libbey, influenced by the interests of his wife, Florence Scott Libbey (right), and encouraged by members of the Tile Club, decided to create an art museum in the city. In 1901, he and six others incorporated the Toledo Museum of Art through the support of 100 people who pledged $10 each to be a founding member. (Courtesy of the Toledo Museum of Art.)

The museum's first exhibit was held in the Gardner Building at Madison and Superior. Two years later, the museum moved to this residential building at 1216 Madison, which Libbey remodeled to serve as an exhibit space and home for the director. George Washington Stevens was appointed director that year, despite having no background in art or even a college degree. (Courtesy of the Toledo Museum of Art.)

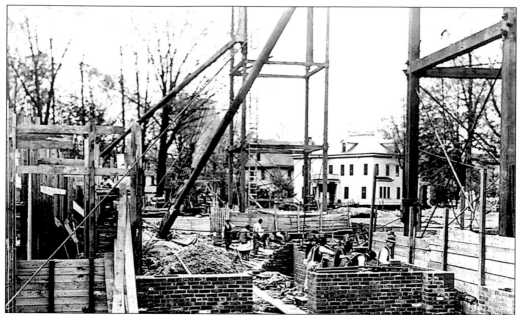

As Libbey's art collecting continued, the Madison Avenue building soon became too small. He and his wife donated the home of Florence's father on Monroe Street as the site for a new museum after Toledoans enthusiastically raised over $50,000 in support. Architects Edward B. Green and Harry W. Wachter designed the Greek Revival structure. The new museum opened its first exhibit on January 17, 1912, to a huge crowd. (Courtesy of the Toledo Museum of Art.)

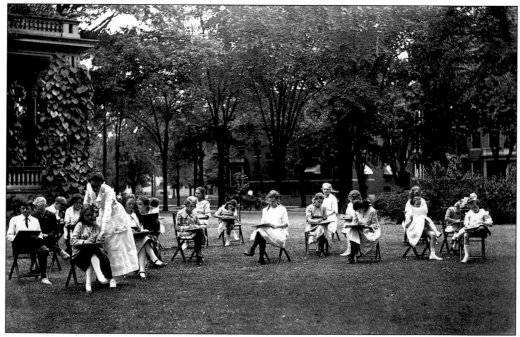

From the beginning, the Toledo Museum of Art's mission included art education, with a special emphasis on children. (Courtesy of the Toledo Museum of Art.)

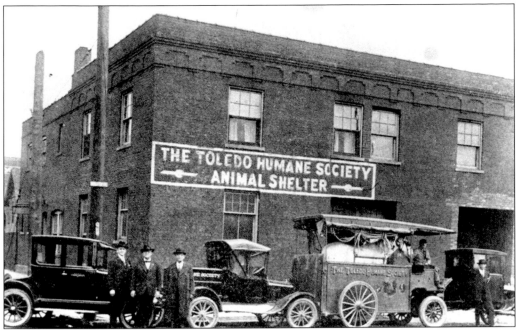

The Toledo Humane Society was founded in 1884 as one of the first in the nation. The original purpose of the organization was to prevent cruelty to both animals and children. A shelter for animals was built in 1918 at Eleventh and Wabash, and the organization was one of the first in Toledo to provide an ambulance service for emergencies.

The Miami Children's Home began as the Protestant Orphans' Home in 1867, when it was created by a group of philanthropists concerned for orphaned and homeless children. The institution sought to place orphans in permanent homes and to be self-sufficient by producing its own food and clothing. In 1890, the county took over the facility, located along the banks of the Maumee River in south Toledo.

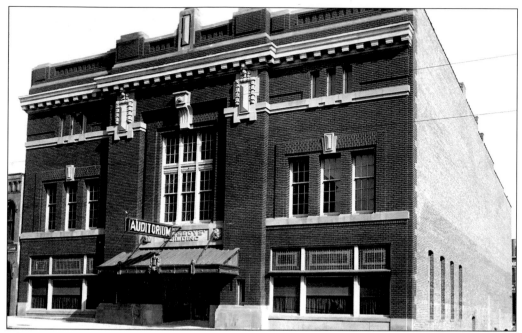

The Toledo Newsboys, a self-governing association of boys who hawked newspapers and shined shoes, was created in 1892 by John Gunckel. It was so successful that in 1911 the group purchased a building on Superior Street to serve as its home. It was believed to be the first such building of its kind where boys could come for recreation, education, and guidance.

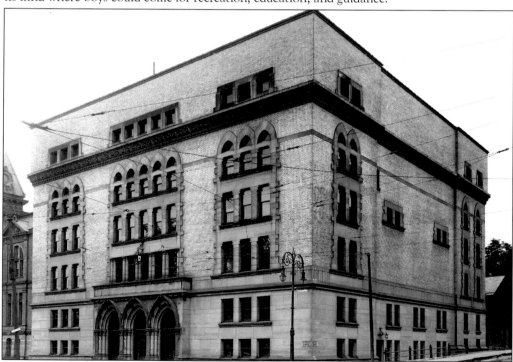

Fraternal organizations were also important to the fabric of the city in the early 20th century. In 1903, work began on a Masonic temple at Adams Street and Michigan Avenue.

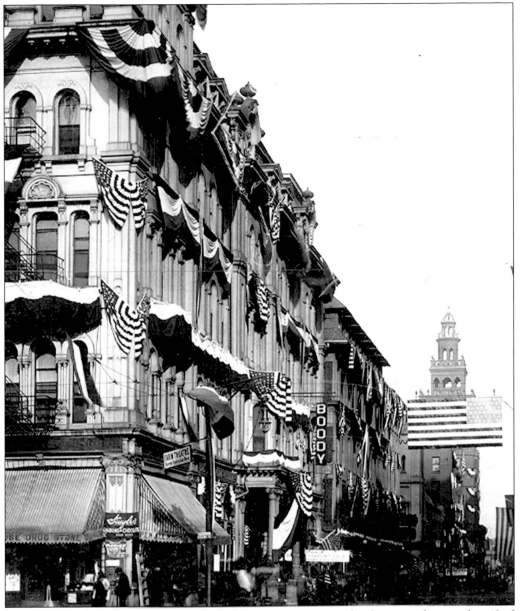

In 1908, Toledo's downtown was decked out in patriotic splendor to welcome the 42nd encampment of the Grand Army of the Republic (GAR), the veterans' organization for those who fought for the Union during the Civil War.

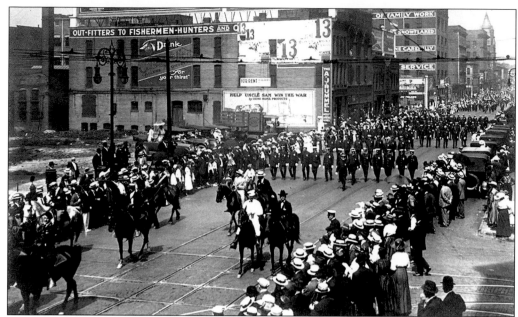

The GAR parade included dignitaries on horseback (above) and others on motorcycles (below).

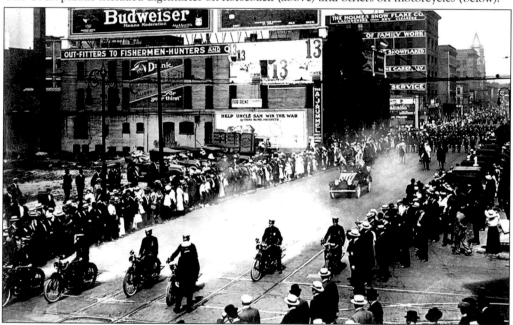

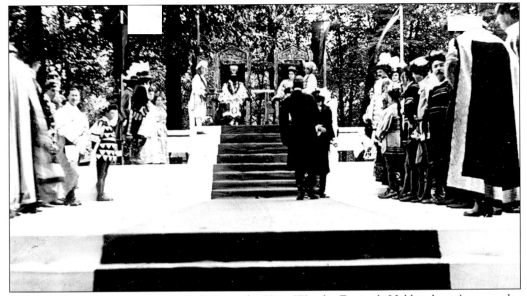

Toledo had its own answer to Mardi Gras: the King Wamba Festival. Held in late August, the party honored the crowning of King Wamba of Spain in the 17th century. A postcard promoting the festival states, "Wamba's reign is spoken of in history as the 'era of Wisdom and Justice,' and the reign of Wamba in the new Toledo will be one of gaiety, hilarity, and joy." Here, King Wamba and his Queen Sancha are crowned.

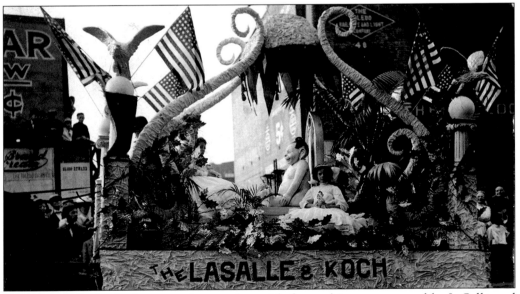

The festival involved a large parade, complete with floats, this one sponsored by LaSalle and Koch department store.

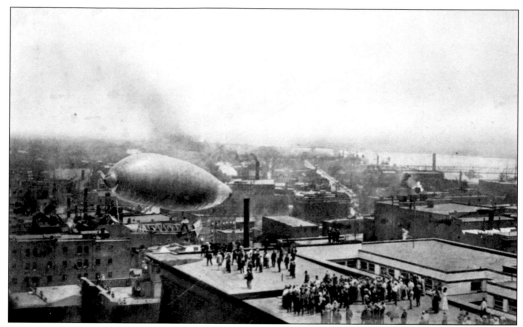

A. Roy Knabenshue of Toledo flew the first successful dirigible flight at the St. Louis World's Fair in 1904. He repeated the feat in Toledo on June 30, 1905, by flying from the fairgrounds on Dorr Street to the roof of the downtown Spitzer building and back again.

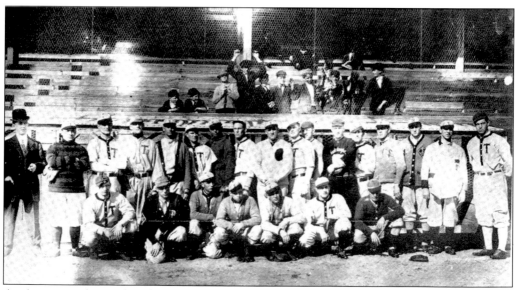

As America urbanized, it found a new pastime: baseball. The Toledo Mud Hens team was a charter member of the American Association in 1901. Noah Swayne, a city lawyer and baseball fan, built one of the best minor-league baseball parks in the nation at the corner of Monroe and Detroit in 1909. Pictured here is the Mud Hens team of 1910.

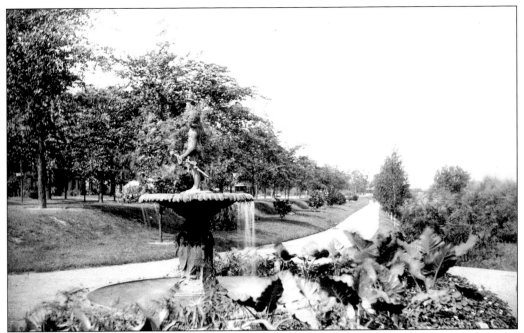

Toledo's municipal reforms included creating city parks in all areas of the city. Sylvanus P. Jermain, who would become parks commissioner, helped pass a levy in 1891 to support building a park system. Located along the Maumee River, Riverside Park was the city's second and contained sculptural fountains and a boathouse.

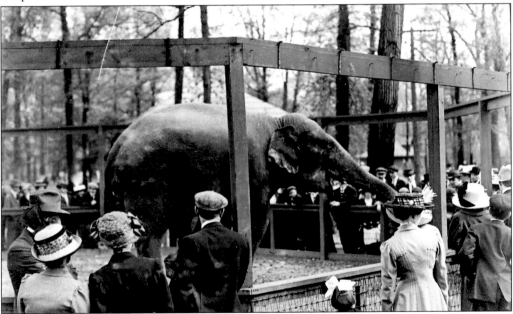

In 1900, a Toledo farmer donated what he thought was a beaver to Milton Moore, superintendent of parks. The beaver turned out to be a woodchuck and was placed in a cage at Walbridge Park. Badgers, an eagle, and bear cubs were added, and in 1905, the city purchased Babe the elephant, seen here, from the Ringling Brothers Circus for $2,400. (Courtesy of the Toledo–Lucas County Public Library.)

Two lion cubs arrived in 1909, and in 1910, the Toledo Zoological Society was created to manage the city's growing animal menagerie. (Courtesy of the Toledo–Lucas County Public Library.)

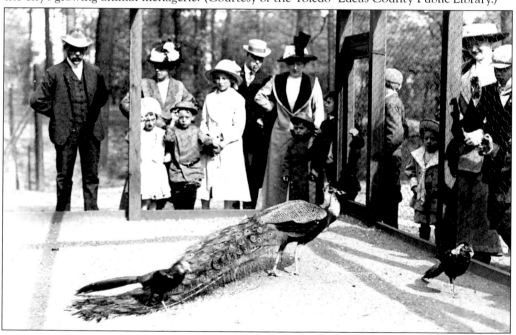

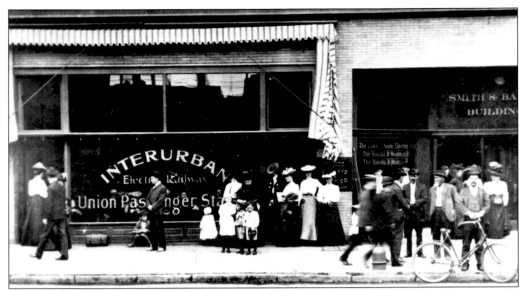

In the early 20th century, Toledo's population began to spread out from the central city. The streetcars and inter-urbans that connected the city to surrounding communities like Perrysburg, Maumee, and Waterville helped promote such expansion. The main inter-urban station was located on Summit Street.

The inter-urbans also made possible many new leisure activities by connecting amusement parks to the city. Toledo Beach became one of the most popular spots for relaxation along Lake Erie, located 16 miles north of the city near Monroe, Michigan, and was advertised on street cars. The area boasted a two-mile stretch of pure white sand. (Courtesy of the Toledo–Lucas County Public Library.)

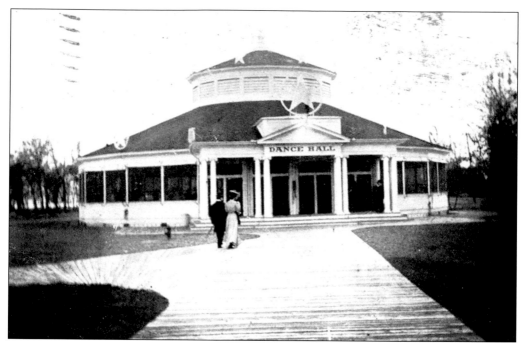

Toledo Beach featured a large dance hall (pictured here), dining hall, water toboggan, bath house, and picnic area.

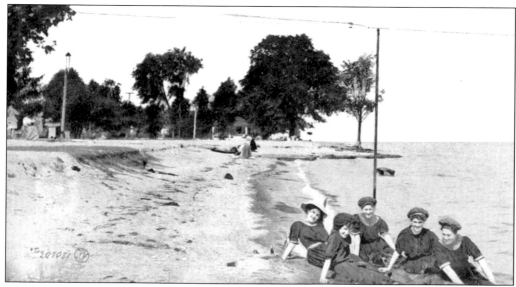

Bathers at Toledo Beach, such as those on this postcard, helped promote the park.

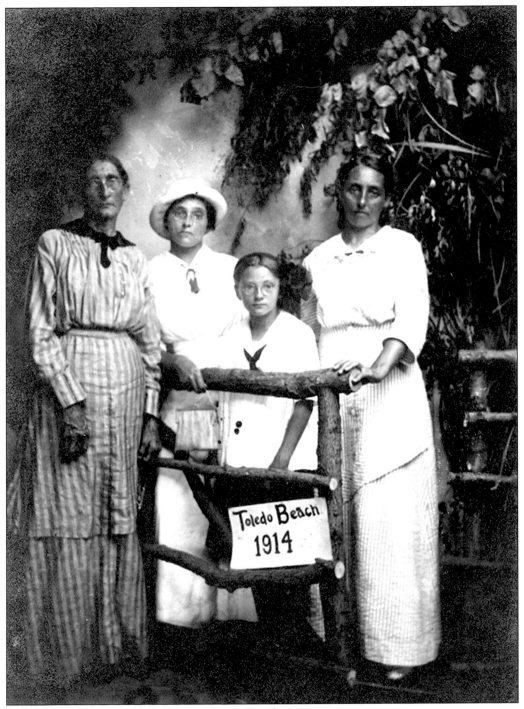

This family photograph was taken at Toledo Beach in 1914.

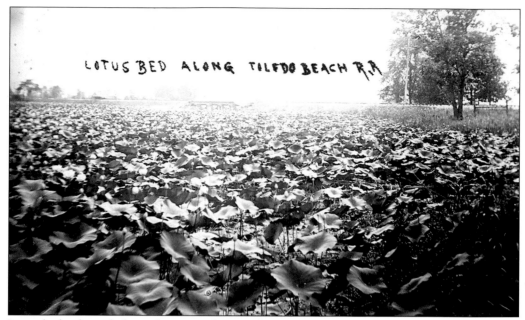

Lotus beds planted along the inter-urban tracks on the way to Toledo Beach bloomed in the summer, creating beautiful displays of pink blossoms.

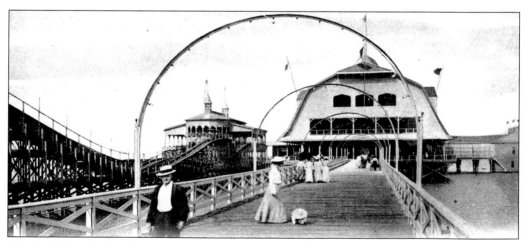

The Lake Erie Park and Casino was located on Summit Street, just outside city limits, and was operated by the Toledo Railways and Light Company. It included a boardwalk, roller coaster, restaurant, ice-cream parlor, and theater. It was a favorite haunt during the summer months.

Toledo had a vibrant live theater district at the dawn of the 20th century, helped by its location on rail lines between New York and Chicago. B. F. Keith's Theatre on St. Clair offered daily vaudeville matinees with a live orchestra.

Other Vaudeville theaters included the Arcade (left) and the Empire (below), also on St. Clair.

44

# Two

# WAR AND DEPRESSION

Toledo's Progressive Era of civic, cultural, educational, and economic reform might have continued had it not been for an unfortunate series of events in central Europe that began to spin out of control in 1914 and in 1917 led the country into its first international war. Thousands of Toledo's residents served in World War I, and 330 died during the brief period of U.S. involvement.

The end of the war began a decade of peace and booming economic prosperity that became known as the Roaring Twenties. Speculative investments in the stock market produced almost instantaneous wealth for some, and fueled the building of new upscale housing developments in Lucas County such as Ottawa Hills. Many other Toledo residents were able to buy more modest homes due to strong growth in city industries such as the production of automobiles. Willys-Overland was one of the largest automobile companies in the country in the 1920s and accounted for 41 percent of the payroll of Toledo in 1925.

Because of the rapid growth of the city, the newly created Lucas County Plan Commission hired Harland Bartholomew, a nationally known planner from St. Louis, to create a unified city plan in 1924. He issued a series of reports that proposed improvements to streets, bridges, railroads, and parks and the construction of a new civic center mall downtown.

In November 1918, Ohio voters approved a statewide prohibition ordinance, and all four of Toledo's breweries closed within a year. In June 1919, the Ohio Legislature gave women the right to vote, and the federal government soon made it a national right. Without drink, sports became a major means of entertainment. The city was the site for one of boxing's biggest fights in 1919, when Jack Dempsey defeated Jess Willard for the heavyweight championship. The Toledo Mud Hens, coached by manager Casey Stengel, won the national pennant in 1927. Inverness Golf Club served as the site for two national championships. The Trianon Ballroom opened in 1925. The Paramount Theater, built at a cost of $2 million, opened in 1929. The Valentine Theater converted from a live stage theater to a movie theater, becoming a favorite place to view the latest releases from Hollywood.

Economically, major changes occurred in Toledo industry and commerce during the 1920s. In 1929, the Owens Bottle Company acquired Illinois Glass and merged to create Owens-Illinois. The following year, the Libbey-Owens Sheet Glass Company merged with Ford Plate Glass to create Libbey-Owens-Ford. Radio became a means of both communication and entertainment, and Toledo's first radio station, WTAL, began broadcasting in 1921 from the Waldorf Hotel downtown. George Storer bought the station in 1928 and renamed it WSPD.

The banks that backed the mortgages for Toledo's booming housing market flourished. Some built lavish new headquarters to show off their wealth. In 1928, Ohio Savings Bank and Trust started construction of a 25-story skyscraper on Madison Avenue that dominated the skyline of the city. The giant stone edifice symbolized the bank's prosperity and stability. Toledo taxpayers supported the city's seemingly endless bright future by approving a bond levy in 1928 to raise $2.8 million for a new campus for the University of Toledo. Again, Harland Bartholomew guided discussions on the appropriate location for this new campus, suggesting a site on Bancroft Street.

Not everyone was included in the economic prosperity of the 1920s, however. Immigration slowed during World War I as Americans feared the political influence of foreigners in their country. One group that moved into the city in large numbers was African Americans, who came north looking for jobs unavailable in the south. The population of African Americans in Toledo grew from 1,800 in 1910 to over 13,000 by 1930. Because of discrimination, most worked in the poorly paid service sector and experienced difficulties finding adequate housing.

Unfortunately, the prosperity of the 1920s was built on a house of cards. Stock market speculation could not be sustained, and on October 29, 1929, the market crashed, ushering in the worst economic depression of modern time. As the stock market failed, those who had borrowed money to invest were unable to repay their loans. They could no longer afford automobiles, and Willys-Overland began laying off workers due to overproduction and declining demand. The Ohio Savings Bank closed in 1930, leaving its new skyscraper empty. When the banks failed, both workers and merchants were without access to savings. Taxes went unpaid, and the city was caught in the dual bind of declining revenues and new demands on public coffers. Those few with jobs sought to protect them by unionizing. In the spring of 1934, workers at the Toledo Auto-Lite Company went on strike when the company refused to negotiate. In May, the Ohio National Guard was called in to restore order at the plant. The strike turned violent, and two protestors were killed.

Pres. Franklin Roosevelt, elected in 1932, grappled with the economic devastation of the nation. His New Deal focused recovery on massive public investment, assuming control of poor relief, and creating employment through public construction projects. The Civil Works Administration and its successors poured millions into Toledo, some $18 million in 1937 alone. Between these public projects and several large privately funded construction projects, Toledo emerged from the Depression decade with a significantly improved infrastructure. Among its new attributes were a zoo, a major roadway built on the site of the old canal bed, a public library building, a public hospital and tuberculosis hospital, a suspension bridge over the Maumee River, a new university campus, a cathedral, public housing, and an expanded art museum.

By the end of the 1930s, Toledo had slowly recovered from the worst of the economic devastation. But once again, international events began to impact on the country and pull it out of its internal problems and into the world's problems. The toll of the next world war on the nation and the citizens of Toledo would be far greater than that of the first.

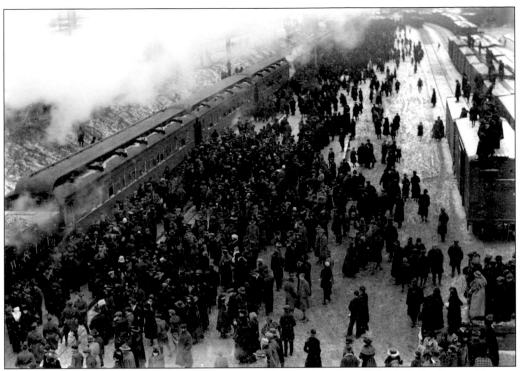

Soldiers depart for service in World War I around 1917. (Courtesy of the Toledo–Lucas County Public Library.)

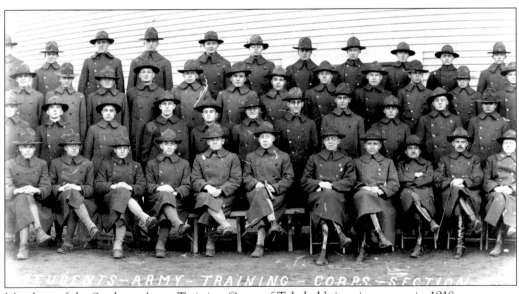

Members of the Students Army Training Corps of Toledo University appear in 1918.

Before World War I, Willys-Overland, second to Ford in worldwide automobile production, manufactured cars for both domestic and export markets.

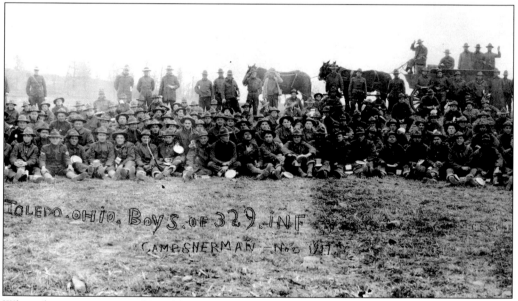

When the country entered World War I, on April 16, 1917, the impact in Toledo was immediate. All men between the ages of 21 and 30 were required to register for the draft, and over 30,000 did so. In July, 862 enlisted men and 22 officers left Toledo for Camp Sherman near Chillicothe, the first troops from the city to report for active duty. By the end of the war in November 1918, some 14,000 men from Lucas County had either enlisted or been drafted. This photograph shows Toledo men of the 329th Infantry at Camp Sherman in November 1917.

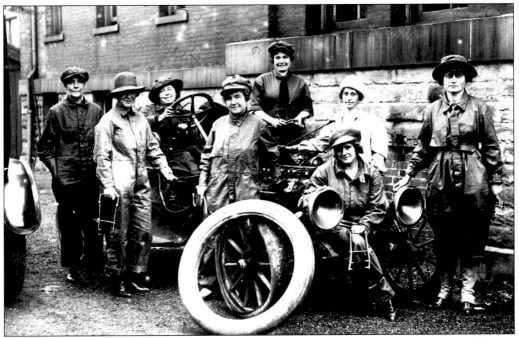

Women joined the war effort as well. Those seen here trained to be automobile mechanics in a program at Toledo University. World War I was the first war to make use of automobiles, especially as ambulances.

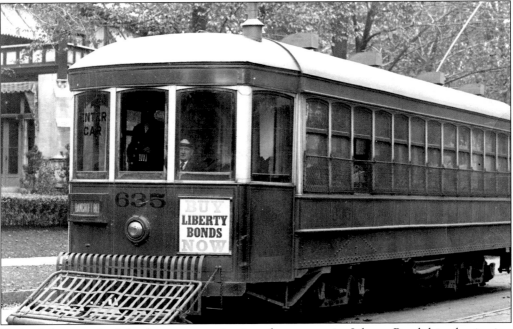

To fund the war, the federal government instituted an aggressive Liberty Bond drive beginning in 1917. Three more drives would follow, and each time, Lucas County exceeded its quota. Liberty Bonds were promoted through advertisements on streetcars. (Courtesy of the Toledo–Lucas County Public Library.)

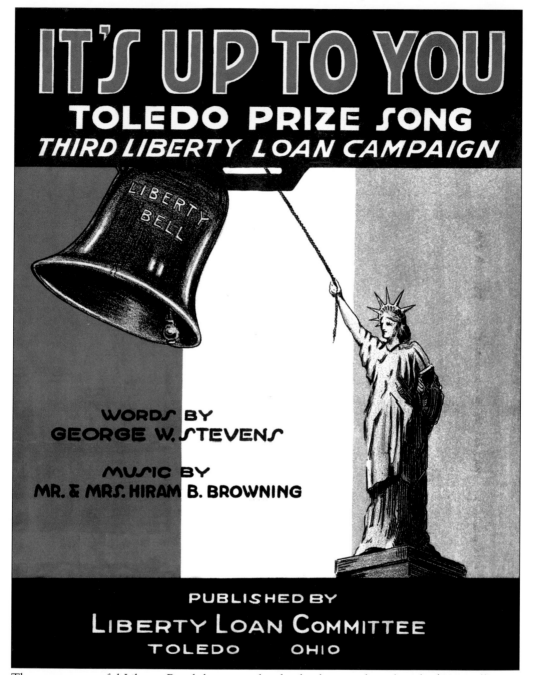

The most successful Liberty Bond drive was the third, when residents bought $14.1 million in bonds—$5 million over the goal—and raised funds faster than any other community in the country. The drive was helped by gimmicks such as this song, written by Toledo Museum of Art director George Stevens.

The Boody House hotel is pictured in 1920. (Courtesy of the Toledo–Lucas County Public Library.)

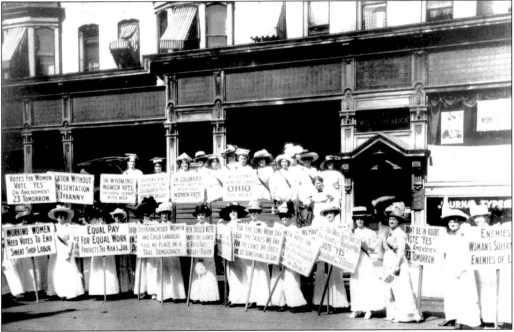

The Toledo Woman's Suffrage Association was a national leader in the fight for the right to vote. Its members, including Sarah S. Bissell and Pauline Steinem, were associates of the national leaders of the movement. The group's newsletter, the *Ballot Box*, was distributed around the country. The 19th amendment was ratified in Ohio in 1919, and the Toledo Woman's Suffrage Association then evolved into the League of Women Voters. (Courtesy of the Toledo–Lucas County Public Library.)

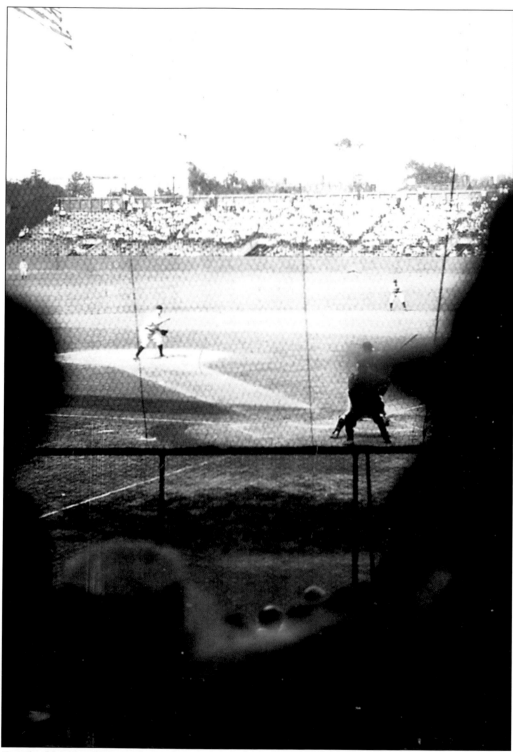

Coached by Casey Stengel, the Toledo Mud Hens won the national pennant in 1927. The team, shown here, played at Swayne Field. (Courtesy of the Toledo–Lucas County Public Library.)

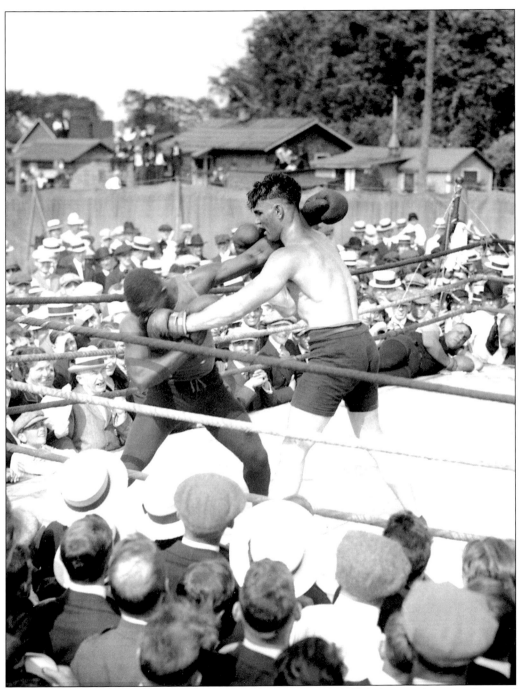

Boxing was almost as popular as baseball in the city. In 1919, Toledo was the site of one of the most important fights of the century when Jack Dempsey defeated heavyweight champion Jess Willard at Bay View Park. Here, Willard (right) spars with his partner prior to the fight. (Courtesy of the Toledo–Lucas County Public Library.)

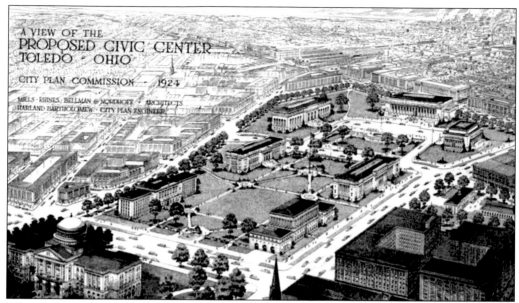

After the war, the country experienced a period of unprecedented growth and prosperity. The Toledo City Plan Commission, organized in 1916, issued a series of reports between 1924 and 1928 developed by Harland Bartholomew, a nationally known city planner. These reports called for improved streets and bridges downtown, improved railway systems, and additional parks. The plan shown here, designed by the Toledo architectural firm of Mills, Rhines, Bellman, and Nordhoff, was for the civic center downtown.

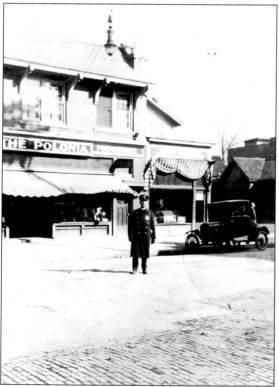

The number of new immigrants settling in the city declined in the 1920s because of restrictions put in place during the war. The Polish village's Lagrange Street is pictured here about 1927. (Courtesy of the Toledo–Lucas County Public Library.)

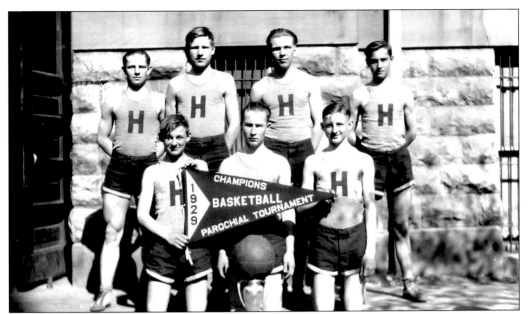

The Polish community on Lagrange Street centered not only its religious life but also its social life around St. Hedwig. The church's basketball team captured the city parochial school championship in 1929. (Courtesy of the Toledo–Lucas County Public Library.)

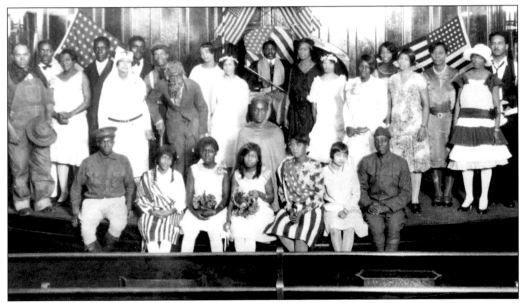

The African American population of Toledo soared in the first three decades of the 20th century as economic opportunities encouraged many to move north. In 1930, over 13,000 African Americans were counted in the city's census. Most settled in the southwestern part of the city due to segregation. This 1928 photograph shows the Dramatic Arts Club of the Third Baptist Church, located on Division Street. (Courtesy of the Toledo–Lucas County Public Library.)

Developers began major new residential housing developments in the period after the war. The Old West End was desirable because the neighborhood featured large front lawns, trees, and beautiful homes.

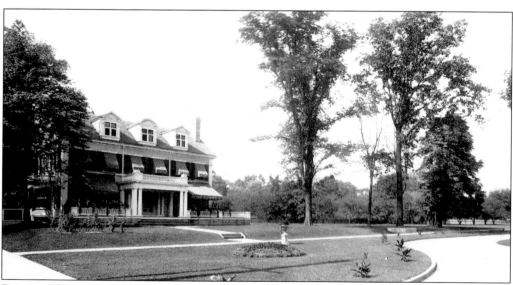

Bronson Place, a secluded, private development, was incorporated in 1913. It included open park spaces in its plans. Some of the homes were designed by Harry Wachter, who helped design the Toledo Museum of Art.

Toledo's newspapers went through a period of consolidation brought about by fierce competition. In 1899, the *Toledo Times*, successor to the *Toledo Commercial*, became the city's morning paper. In 1876, the *Evening Bee*, later known as the *Toledo Bee*, started as an afternoon paper. The *Toledo News*, organized in 1881, was one of the city's leading papers in 1900, when it was sold to the *Toledo Times*. It merged with the *Bee* in 1902 to become the *Toledo News-Bee*. By 1922, the city had three major newspapers: the *News-Bee*, the *Times*, and the *Blade*, located in this building on Superior Street.

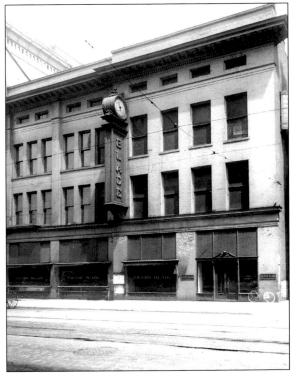

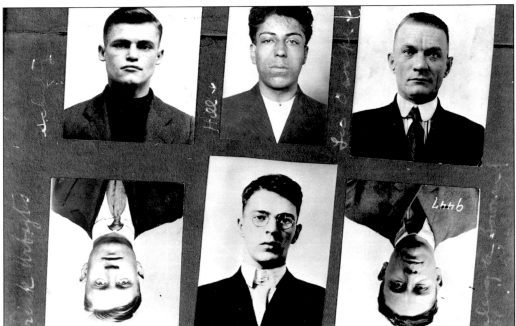

In 1921, Toledo was the scene for a major mail heist by Joe Urbaytis (upper right) and his gang. The gang made off with 10 sacks of U.S. mail, including currency and Liberty Bonds being shipped by the federal government. Urbaytis escaped from the Lucas County Jail in September of that year and was captured three years later. He eventually served his sentence in Alcatraz. (Courtesy of the Toledo–Lucas County Public Library.)

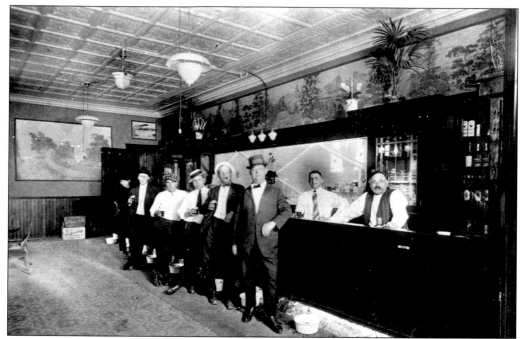

As the war ended in 1918, Ohio voters passed a statewide prohibition ordinance, and within six months, all of Toledo's breweries closed. The city's thriving saloon scene vanished overnight, replaced by speakeasies.

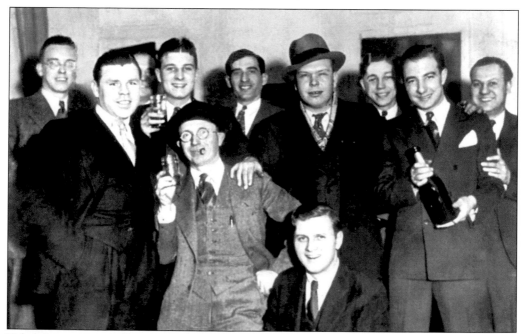

Toledo's proximity to Detroit made it a favorite haunt for bootleggers and mobsters. The Purple Gang, shown here, was led by Thomas "Yonnie" Licavoli. In addition to trying to control the illegal liquor trade, the gang sought to control the numbers racket and demand protection money from businesses. (Courtesy of the Toledo–Lucas County Public Library.)

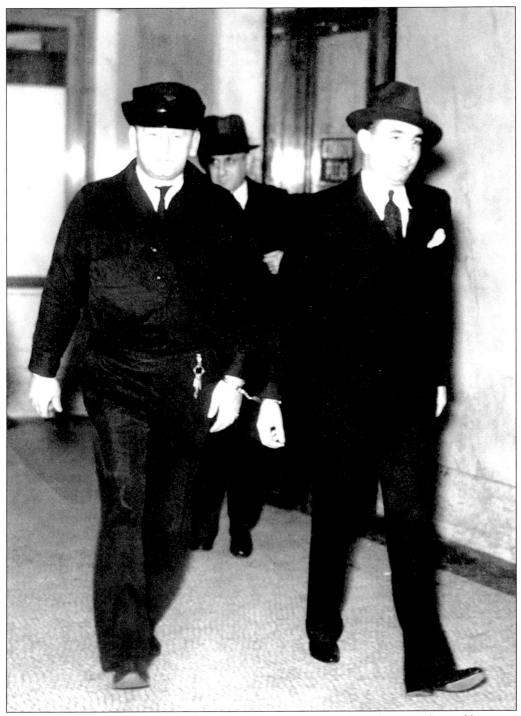

After avoiding prison time for his bootlegging business, Licavoli and 13 members of his gang were found guilty of murder and conspiracy in the death of nightclub owner Jackie Kennedy in 1934. (Courtesy of the Toledo–Lucas County Public Library.)

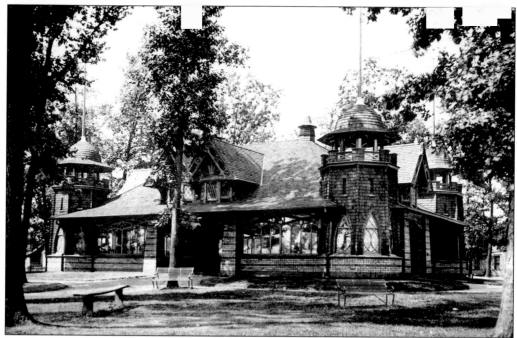

The Bartholomew Plan emphasized creating a network of parks in the city. Navarre Park, on the east side, was acquired by the city in the 1920s and featured a pavilion for dances and social events.

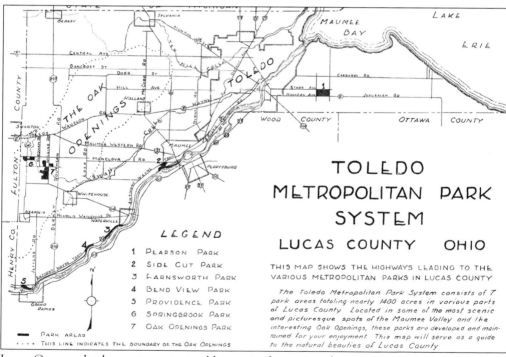

Lucas County also began to protect wild areas in the surrounding communities by developing a metropolitan park system. The Toledo Metropolitan Parks Board, organized in 1929, established seven parks, many of them along the Maumee River.

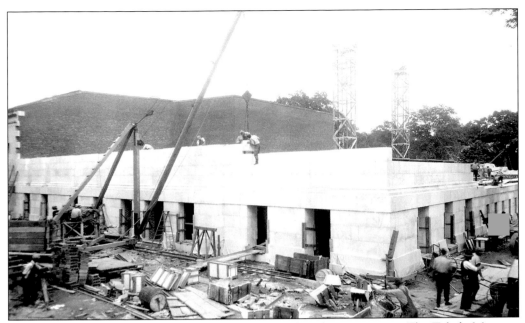

The vitality of the city in the 1920s extended to its cultural organizations. The Toledo Museum of Art quickly outgrew its facility and, in 1924, started a period of expansion to produce new gallery spaces. Unfortunately, the museum's founder, Edward Drummond Libbey, died two months before the expansion was completed. (Courtesy of the Toledo Museum of Art.)

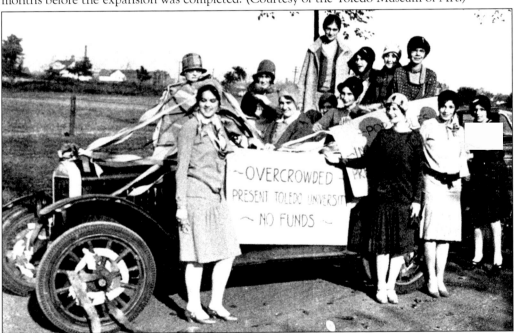

Henry J. Doermann, who became the University of Toledo's new president in 1928, quickly recognized that the ultimate success of the university rested on finding a permanent home. He convinced city fathers to place a bond levy issue on the November 1928 ballot to raise $2.8 million for a new campus. Faculty and students campaigned door to door to gather support for the measure, which ultimately passed by 10,000 votes.

After much debate as to where the new university should be located, the board of directors settled on this site on Bancroft Street because of its proximity to most of Toledo's population.

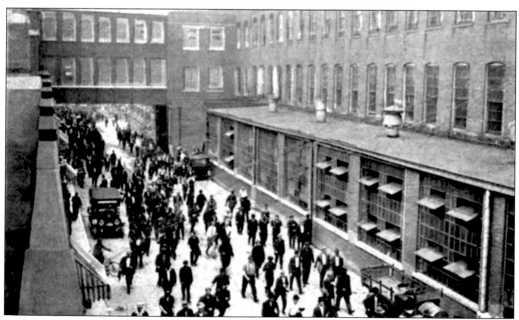

In the 1920s, Willys-Overland dominated the economy of the city. Over 40 percent of the city's payroll was generated by the plant. The company produced 300,000 cars in 1928 and employed over 20,000 Toledo residents. But these high production rates eventually led to a surplus of automobiles that could not be sold. In April 1929, the plant began laying off workers, even before Black Tuesday.

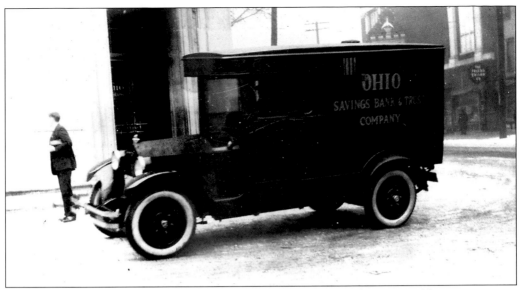

The Ohio Savings Bank became a symbol of the city's post-war boom. In addition to its new skyscraper under construction downtown, the bank had a fleet of shiny black trucks that transported money to the branches. (Courtesy of the Toledo–Lucas County Public Library.)

While Toledo had begun to experience some economic hiccups even before Black Tuesday, the stock market crash of 1929 led to a $6 million drop in bank deposits. With some 16,000 residents out of work and banks holding mortgages to homes which workers could no longer afford, the banks began to fail. In June 1931, the Security Home Trust Company failed to open. Four others soon followed. Both workers and merchants were unable to access their accounts.

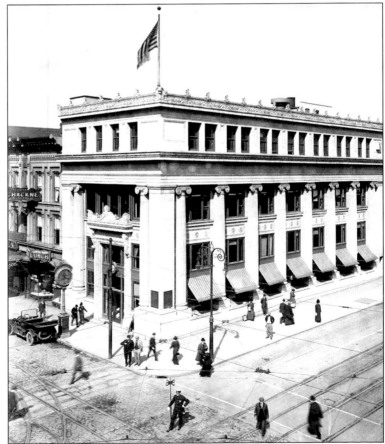

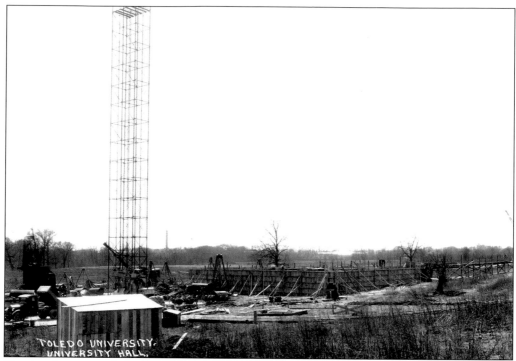

Despite the onset of the Depression, work began on the new university campus in 1929 and provided work to over 400 people. Plans for the major campus building called for Collegiate Gothic architecture, which is dominated by a large central tower, seen here as just scaffolding. President Henry Doermann faced criticism over the extravagance of the architecture, which seemed lavish amidst the economic hardship.

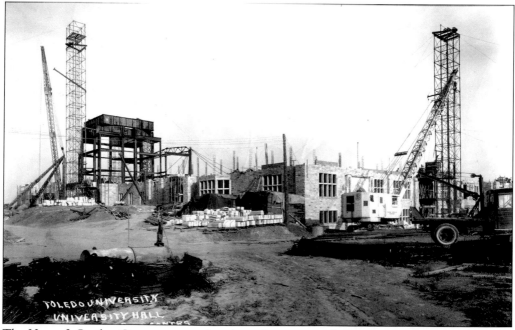

The Henry J. Speiker Company served as general contractor during the campus construction.

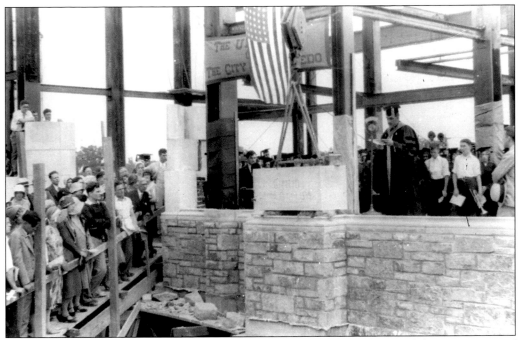

Commencement ceremonies for the class of 1930 coincided with the laying of the cornerstone of University Hall. Dr. Doermann, in his academic robes, presided over the ceremony.

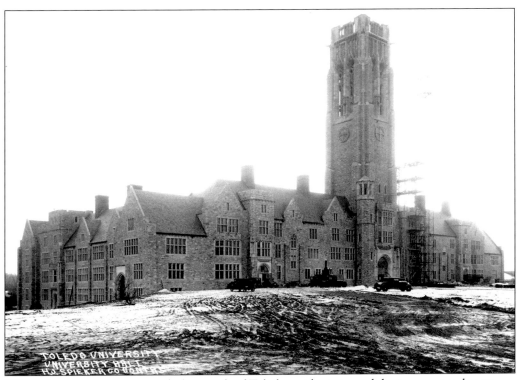

When the new campus opened, thousands of Toledo residents toured during an open house.

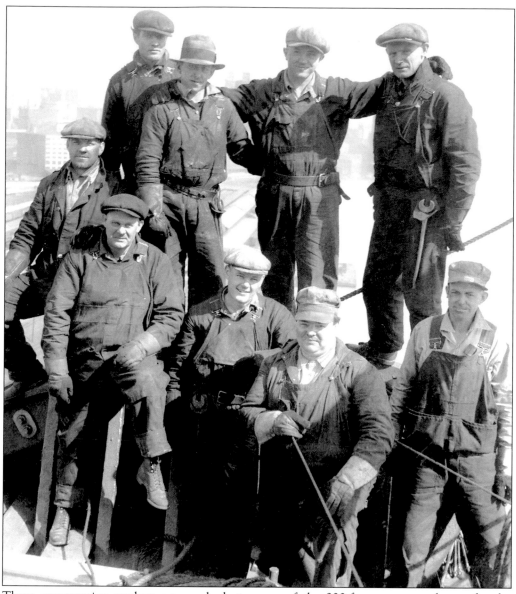

These construction workers are perched atop one of the 200-foot support columns for the Anthony Wayne Bridge, which opened in 1931. Often called the High Level Bridge, it cost $3 million to build. (Courtesy of the Toledo–Lucas County Public Library.)

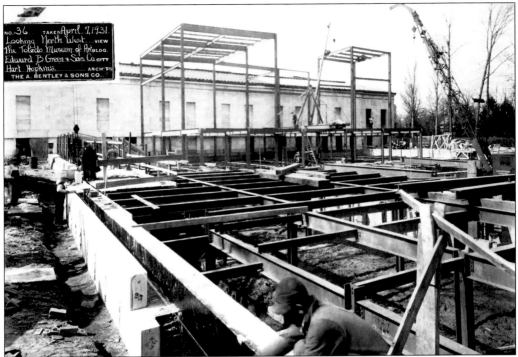

Another important construction project began in 1926, when Florence Scott Libbey, the widow of Edward Drummond Libbey, began further expansion of the Toledo Museum of Art. In his will, Libbey had left $2 million for a new music auditorium. His widow expanded the project to include a new art school built on the land where her uncle William Scott's home stood. The project, including the construction of the new music hall named the Peristyle, employed 2,500 people. (Both courtesy of the Toledo Museum of Art.)

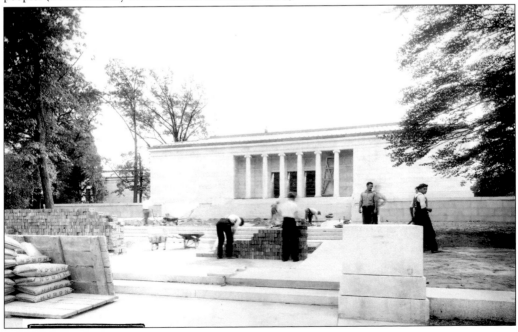

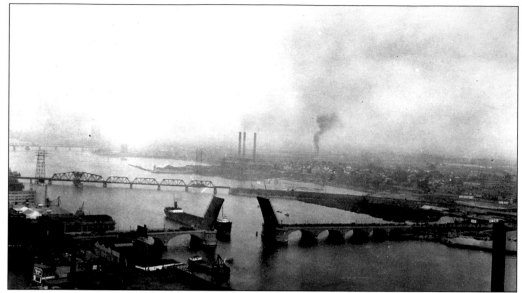

Despite some privately financed construction projects, the unemployment rate in Toledo quickly skyrocketed. By September 1931, some 5,000 destitutes were on public relief. One year later, that number had almost tripled. Already hit by $6 million in delinquent tax payments, the city had little money for relief. Fortunately, in 1933, the Federal Emergency Relief Administration took over poor assistance. Toledo was described as the hardest hit city in Ohio.

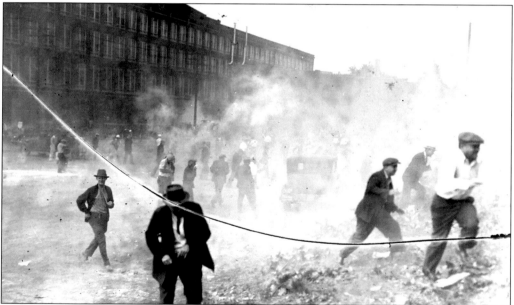

With so many unemployed, unionized workers found it difficult to negotiate for better wages or working conditions. In 1934, management at the Toledo Auto-Lite Company refused to recognize workers who had organized under the American Federation of Labor. In April, the company fired the workers and called in strike breakers to man the plant. The situation grew tense, and the Ohio National Guard attempted to restore order. On May 24, the strike turned bloody in what became known as the Battle of Chestnut Hill. This photograph shows evidence of the violence; the glass negative was cracked when the guards fired at strikers throwing rocks.

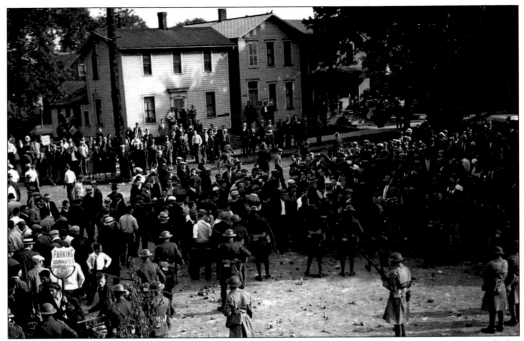

Two workers were killed during the Battle of Chestnut Hill. (Photographs courtesy of the Toledo–Lucas County Public Library.)

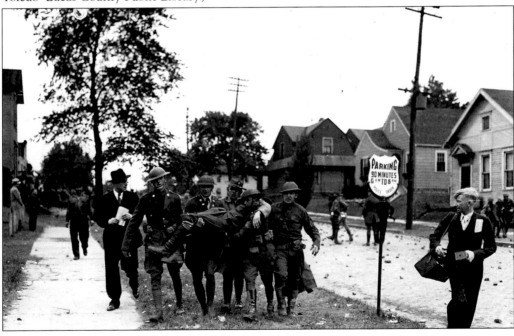

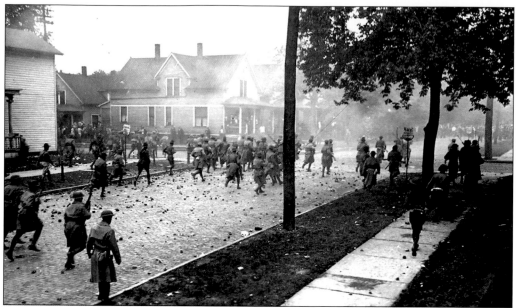

The Auto-Lite strike became a rallying cry for workers, and was fundamental in the founding of the United Automobile Workers international union. (Both courtesy of the Toledo–Lucas County Public Library.)

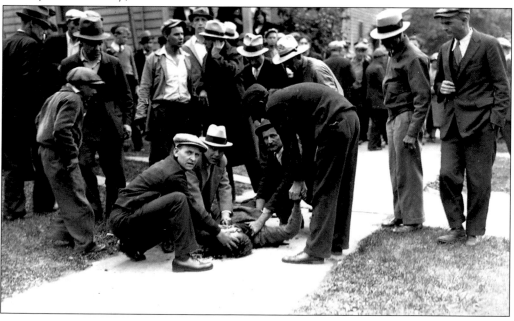

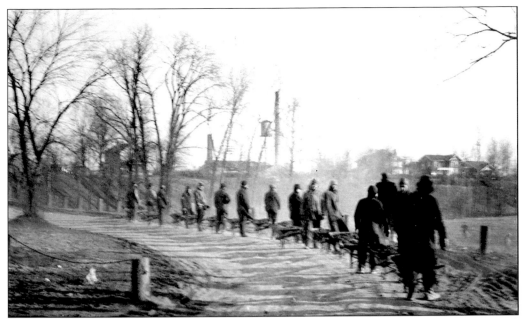

Pres. Franklin Roosevelt's New Deal poured millions into the city for numerous public work projects. The Civil Works Administration employed 15,000 in 1933. These workers were paid 50¢ per hour to do back-breaking work like reclaim the abandoned Miami and Erie Canal, which was paved over as Canal Boulevard (and later re-named the Anthony Wayne Trail). Federal funds were also used to improve the city's parks, including Ottawa Park in West Toledo, shown here.

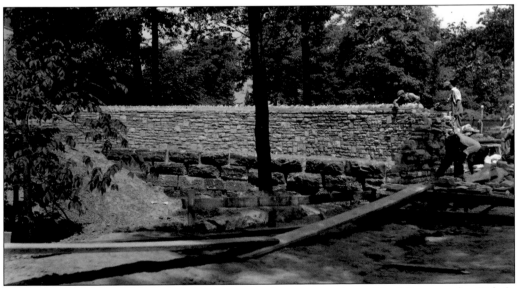

The most important public works project was the construction of buildings at the Toledo Zoo. The Civil Works Administration and its successor, the Works Progress Administration, appropriated $500,000 to improve it. The Reptile House was built using salvaged materials from the Miami and Erie Canal and the old Milburn Wagon Works building to control construction costs. Here, workers construct a retaining wall at the zoo in 1934. (Courtesy of the Toledo–Lucas County Public Library.)

## PROGRAMME

OPENING CONCERT

July 16th, 1936

COMMUNITY "SING"

Sunday, July 19th, 8:00 P. M.

TOLEDO ZOOLOGICAL SOCIETY

Also built by the Works Progress Administration, the Amphitheater opened with a community sing in 1936.

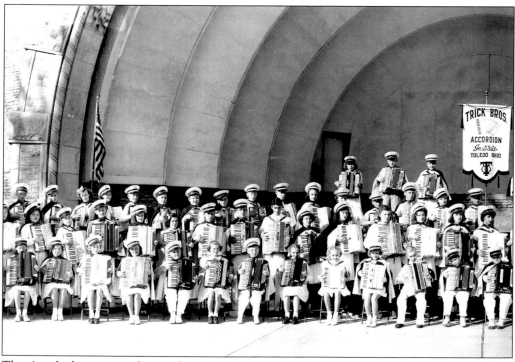

The Amphitheater was the site for many community musical events, including this accordion recital by the students of the Trick Brothers Accordion Institute in 1942.

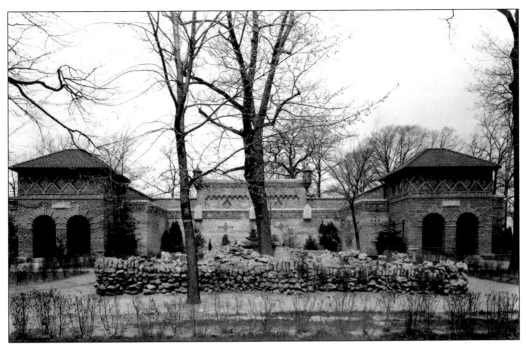

Other zoo buildings constructed with public funds included the Monkey House, the Aviary (shown here), a pedestrian subway under the new Canal Boulevard, and the Museum of Natural History. (Courtesy of the Toledo–Lucas County Public Library.)

The Works Progress Administration was also contracted to build a new football stadium at the University of Toledo, at a cost of $350,000. The site took advantage of a natural bowl shape in the campus landscape.

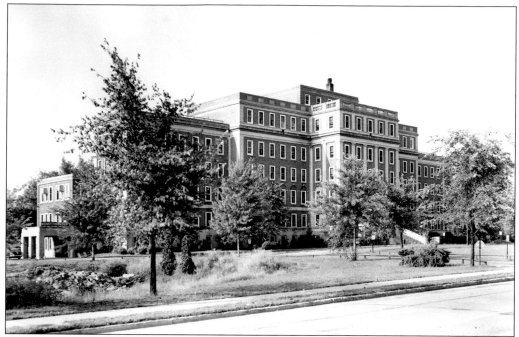

In 1931, the $850,000 Maumee Valley Hospital opened at Detroit and Arlington Avenues. It served as the county's public hospital, treating the poor and indigent.

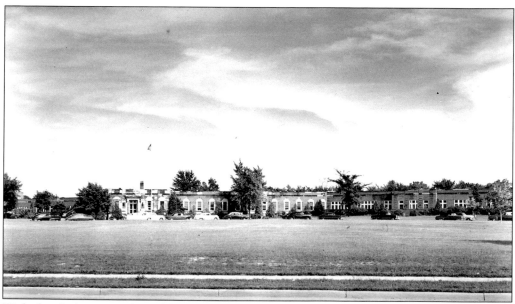

With the declining quality of life brought about by unemployment and hunger, public health suffered during the Depression. Rates of typhoid fever, diphtheria, and tuberculosis were all high in the city, according to a survey conducted by the U.S. Public Health Service in 1937. That year, the Works Progress Administration financed the construction of the William Roche Memorial Hospital for the treatment of tuberculosis, adjacent to the new Maumee Valley Hospital. Tuberculosis remained a chronic problem in the city. In 1940, the hospital was so overcrowded that many infected with the disease had to remain at home.

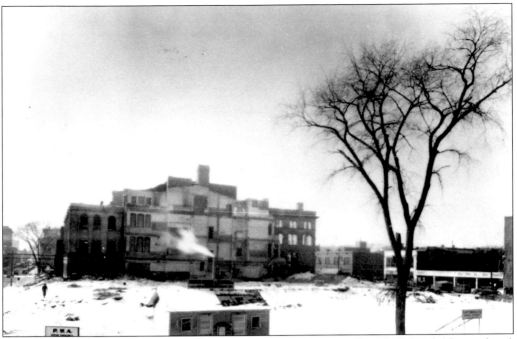

The Works Progress Administration demolished the old Central High School (shown here) and constructed a new public library building on its Michigan Avenue site. (Courtesy of the Toledo–Lucas County Public Library.)

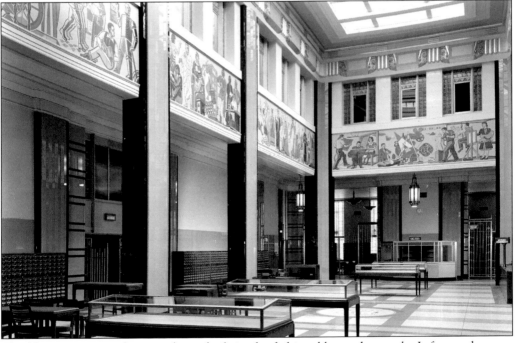

The library was an architectural gem built in the fashionable art deco style. It featured scenes of Toledo's industrial history created using a glass product called Vitrolite, produced by Libbey-Owens-Ford.

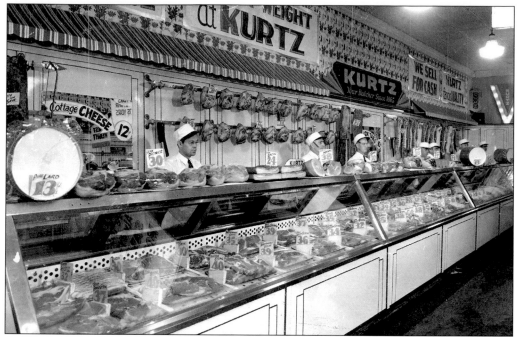

Established in 1865, Kurtz's Meat Market on Summit Street was one of the city's most popular butcher shops. This photograph shows the store in 1937.

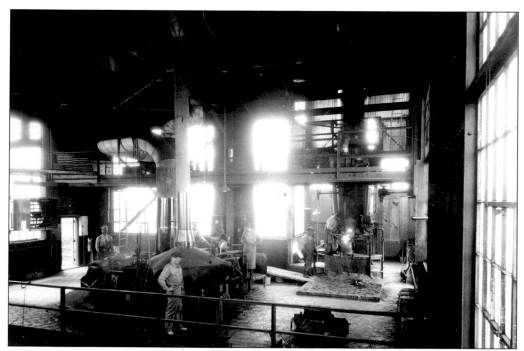

While Toledo did not develop a large steel industry like Cleveland or Youngstown, casting companies were still important to the local economy. The Industrial Steel Castings Company, seen in 1936, was located on Millard Avenue at Front Street.

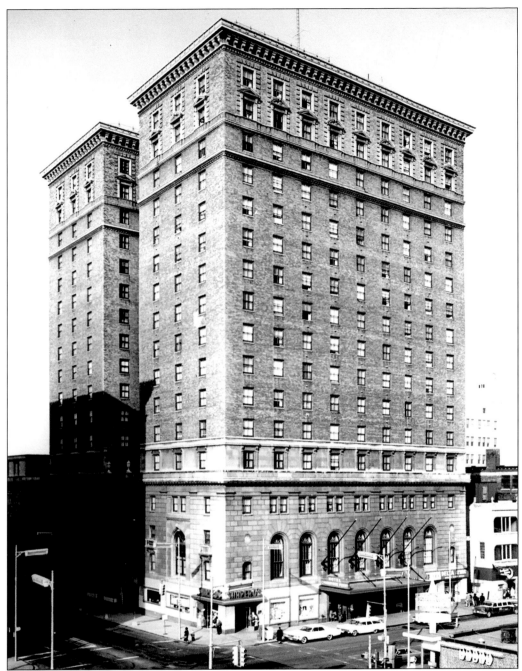

The Commodore Perry Hotel was built downtown in 1927 and was one of the largest in the Midwest for its time. Its architecture was more modern than classical, and it quickly became a spot for the "in" crowd in Toledo as well as a favorite among travelers.

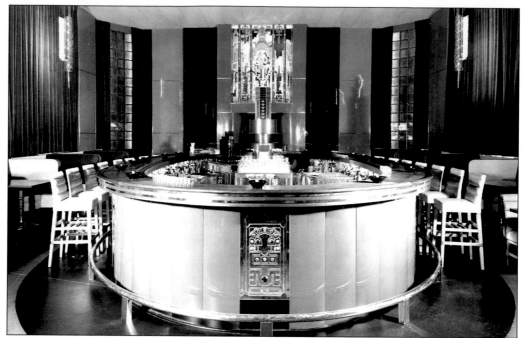

The bar at the Commodore Perry Hotel reflected the influence of art deco architecture with its sleek, simplified, and modern style using Vitrolite, a favored art deco building material.Vitrolite had a national influence on architecture from the 1920s to the 1950s, and was produced by Libbey-Owens-Ford.

The slums of the inner city stood in sharp contrast to the opulence of the Commodore Perry. With the help of federal money, the new Metropolitan Housing Authority began the first public housing project, Brand Whitlock Homes, in 1936. It was expanded again in 1940. (Photographs from the Toledo-Lucas County Public Library.)

Despite the Depression, Toledo boasted a thriving theater district. In 1935, the Paramount brought Ethel Barrymore to town in *The Constant Wife*. The play was directed by Flora Ward Hineline, a Toledo socialite and cultural promoter.

PARAMOUNT THEATRE
TOLEDO, OHIO

**Monday Evening, October 14, 1935**

Curtain at 8:30

S. E. COCHRAN
has the honor to present

ETHEL BARRYMORE

— in —

"THE CONSTANT WIFE"

— by —

W. Somerset Maugham

Legitimate attractions in this theatre
Direction FLORA WARD HINELINE

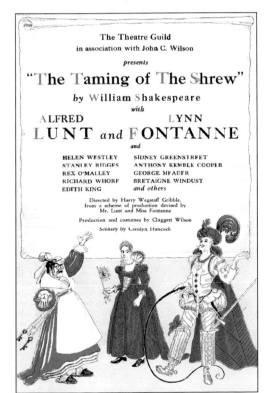

The Theatre Guild
in association with John C. Wilson

*presents*

"The Taming of The Shrew"

*by* William Shakespeare

*with*

ALFRED          LYNN
LUNT *and* FONTANNE

*and*

| | |
|---|---|
| HELEN WESTLEY | SIDNEY GREENSTREET |
| STANLEY RIDGES | ANTHONY KEMBLE COOPER |
| REX O'MALLEY | GEORGE MEADER |
| RICHARD WHORF | BRETAIGNE WINDUST |
| EDITH KING | *and others* |

Directed by Harry Wagstaff Gribble,
from a scheme of production devised by
Mr. Lunt and Miss Fontanne

Production and costumes by Claggett Wilson
Scenery by Carolyn Hancock

Also appearing at the Paramount were Alfred Lunt and Lynn Fontaine in *The Taming of the Shrew*.

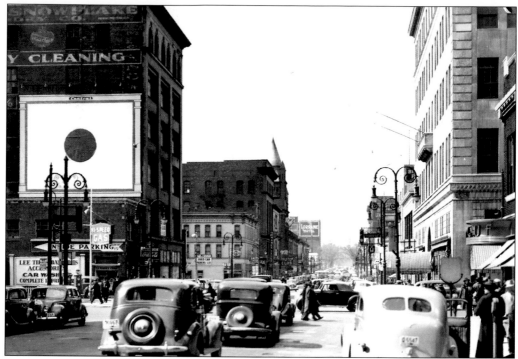

As the country recovered from the Depression, Toledo's downtown shopping district also began to bounce back, as seen in this 1936 photograph.

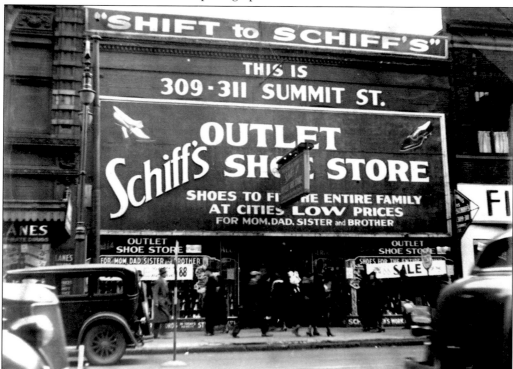

Shown here is Schiff's Shoe Store on Summit Street.

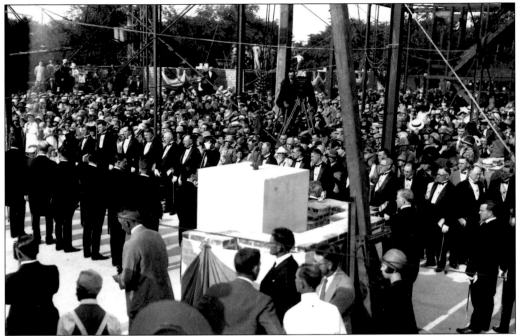

Construction of the Queen of the Most Holy Rosary Cathedral started in October 1925, and the cornerstone was placed in 1926. The building was completed in 1931 and dedicated in October 1940. The dedication program described the project as "a sublime act of religious faith and devotion." This description must have felt all too true during the darkest days of the Depression. These images trace the long construction process from its cornerstone laying to its dedication. (Both courtesy of the Toledo–Lucas County Public Library.)

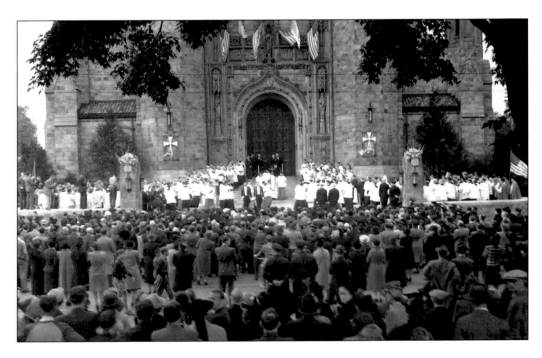

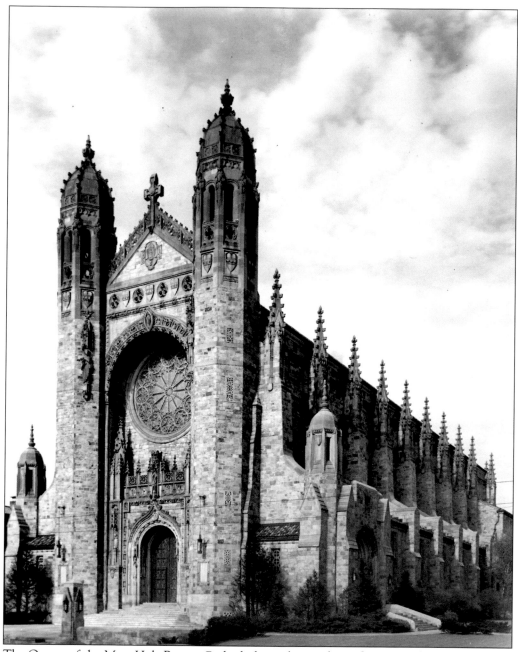

The Queen of the Most Holy Rosary Cathedral was designed to reflect Spanish architecture, in honor of Toledo's sister city in Spain. (Courtesy of the Toledo–Lucas County Public Library.)

# *Thee*

# WAR AND PROSPERITY

By 1938, the menacing events unfolding in Europe could no longer be ignored. Pres. Roosevelt increased U.S. military spending after Hitler's Germany marched into the Sudetenland and Czechoslovakia. The United States attempted to maintain its neutrality, but helped the Allied forces by providing weapons and equipment to stop the aggression. All pretenses of neutrality ended on December 7, 1941, when the Japanese bombed Pearl Harbor. On December 8, Congress voted to go to war against the Japanese, and three days later, Germany and Italy declared war on the United States.

Because of its location in the industrial heartland and on an interior shipping line, Toledo was declared a strategic inland defense area early in the war. This required citizens to be prepared against attack through a civil defense program. Beginning in 1942, citizens practiced blackouts against possible air assaults.

Personally and economically, the war had a profound impact on the city's residents. On the personal side, over 30,000 Toledo men registered for the draft even before war had been declared. Later, draft registration was expanded to include men up to age 65. The patriotic fervor that swept the country after Pearl Harbor led each of the seven war bonds drives to exceed their goals. Local Boy Scouts organized efforts to collect scrap metal like tin cans and bed springs for the war effort. Toledo families made due with limited rations of gasoline, food, and clothing.

Economically, the war helped to pull the city out of the Depression. Between 1941 and 1945, Toledo industry produced over $3 billion in war equipment and supplies, with most factories working three shifts. Willys-Overland became a major supplier of a new "General Purpose," or "Jeep" vehicle with four-wheel drive for difficult terrain. Shell casings were made by Acklin Stamping, and fighter jet nose cones were produced by Libbey-Owens-Ford. With men in demand for military service, it was left to women to run the factories. The University of Toledo organized a curriculum to train women for war management and production jobs.

The conflict was long, and brutal. When it ended in August 1945, some 100,000 residents celebrated in the streets and most businesses closed for the celebration. Sadly, 1,195 Lucas County residents did not return from the war. A memorial on the civic center mall was erected in their memory and dedicated on Memorial Day in 1948.

After the war, the city had to adapt to a peacetime economy. Unemployment increased again, though not to pre-war levels. Willys-Overland adapted by modifying its wartime Jeep to a consumer market. Pent-up demands for goods and the baby boom helped to spur on economic growth. One group experiencing particular problems in the post-war economy was African

Americans, who again came north in large numbers in search of better jobs. Between 1940 and 1950, the population of non-whites in Toledo increased from 15,000 to over 25,000, and adequate housing was a serious problem. To ease the new residents' transition, and to assist with racial relations in the city, the Board of Community Relations was created in 1946. Also that year, a new Labor-Management-Citizens Committee was created to replace the Industrial Peace Board, working to mediate labor unrest and avert strikes. Women found they had little place in the post-war industrial world and most returned to the home to work.

Politically, after the war, control of the city passed from the Republican Party to the Democratic. In 1949, voters approved a change to the method of electing city council members—from a complex proportional representation model born during the Progressive Era to a direct election.

Despite the seeming stability of the city, however, the post-war years sowed seeds that would begin to unravel in the next three decades. The end of the war was both a watershed for the city and the beginning of its struggle to regain its once brilliant future.

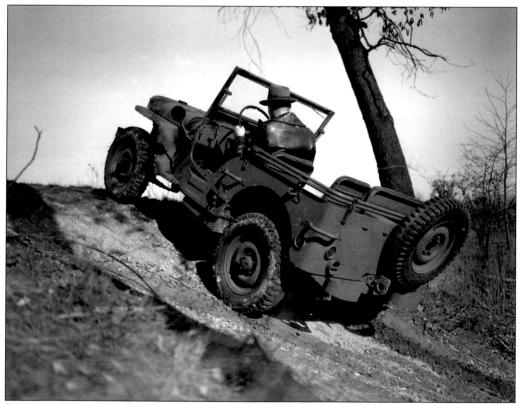

The Jeep was a versatile vehicle that could handle most rough terrain. Production of the Jeep helped to pull Toledo out of the Depression, and it remains a major industry in the city today. (Courtesy of the Toledo–Lucas County Public Library.)

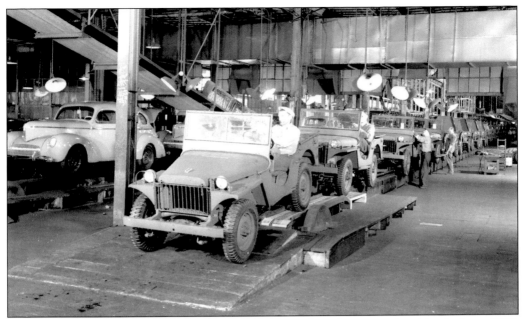

At the height of the Depression, Willys-Overland was forced into receivership. In June 1940, the federal government invited 135 companies to build an experimental war vehicle. Under the leadership of Ward M. Canaday, Willys-Overland was one of three to submit plans, and the government selected the Willys model for production. While the exact root of the word "Jeep" is unclear, it is thought to reflect a combination of "G" and "P" for "General Purpose" vehicle. Between 1941 and 1945, some 300,000 Jeeps were produced in Toledo. (Courtesy of the Toledo–Lucas County Public Library.)

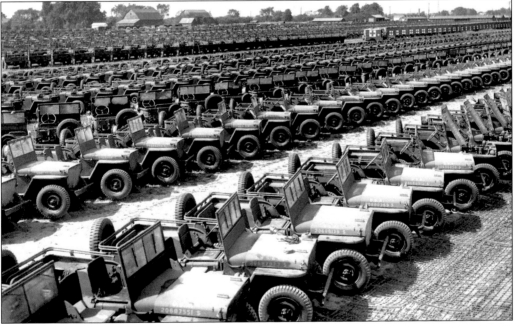

The Jeeps were stored at the Rossford Ordnance Depot until shipped overseas. (Courtesy of the Toledo–Lucas County Public Library.)

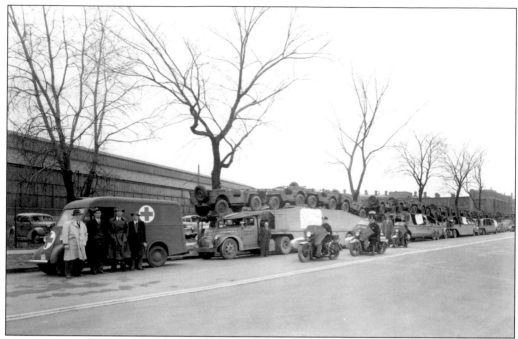

Jeeps are loaded onto transport trucks to be sent to Europe. (Courtesy of the Toledo–Lucas County Public Library.)

As it had in World War I, the government sold bonds to help finance World War II. The leaders of Toledo's business community worked to promote the sale of these bonds, including Robert Stranahan Sr. (Champion Spark Plug, third from left), William Levis (Owens-Illinois, second from left), and John Biggers (Libbey-Owens-Ford, right). (Courtesy of the Toledo–Lucas County Public Library.)

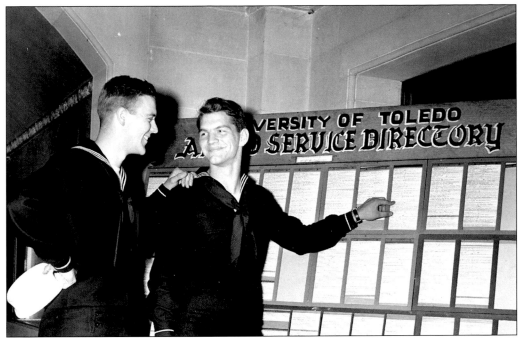

The University of Toledo, still struggling with the aftermath of the Depression and its effects on enrollment, was hit hard by World War II. Nearly 50 percent of the students in the College of Arts and Sciences either dropped out to enlist or were drafted. In the College of Engineering, that figure reached 90 percent. Here, Lyle Clark and Dodd Tonjes check on the location of friends serving overseas.

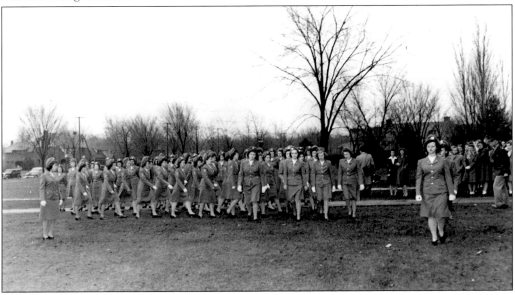

Female students also joined the war effort, including these, who were members of the Army Cadet Nurse Corps. They received their academic training at the university and their medical training at area hospitals. This program, established by Congress in 1943, was part of an effort to enlist 60,000 nurses nationally for the war. Over 3,000 received their training at the University of Toledo, which included drills in military marching.

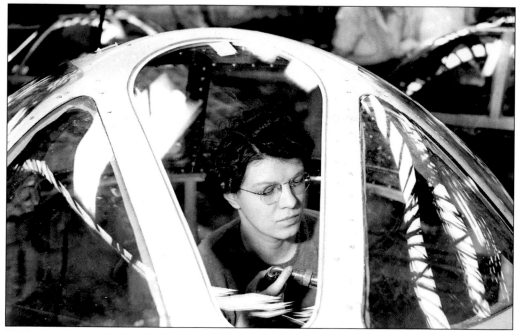

With men joining the military, vital support jobs were left to women to fill. Thus was born "Rosie the Riveter," the symbol of women working outside the home in war production factories. Toledo had its own "Rosies," including these women assembling fighter jet nose cones for Libbey-Owens-Ford.

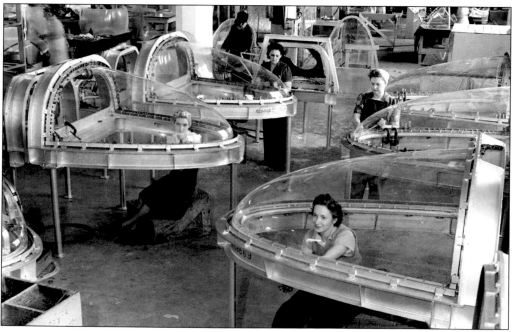

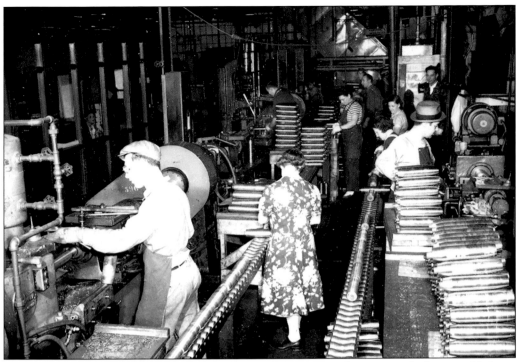

Acklin Stamping produced shell casings for the war. Here, men and women work the assembly line.

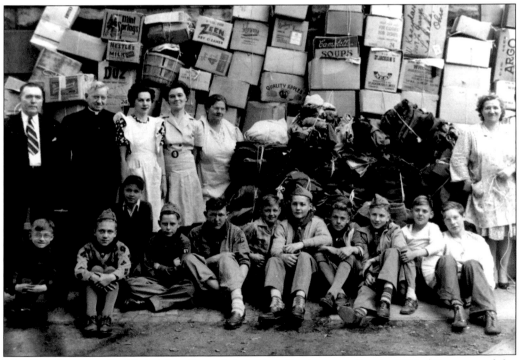

The Boy Scouts at St. Hedwig's collected donations for the war effort in 1945. (Courtesy of the Toledo–Lucas County Public Library.)

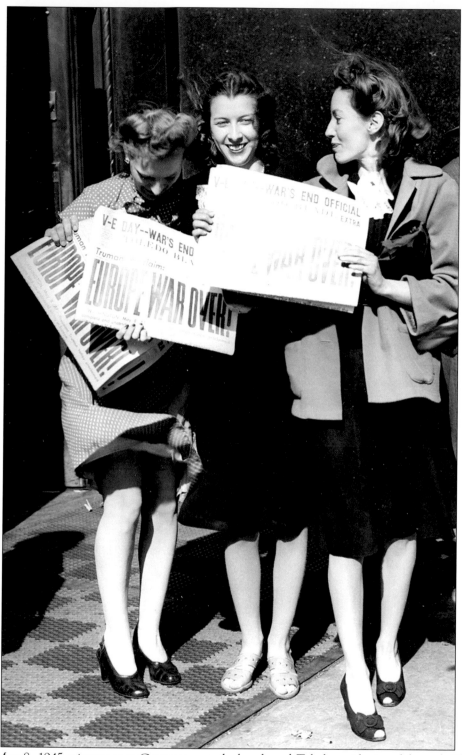

On May 8, 1945, victory over Germany was declared, and Toledo residents celebrated. Three months later, the Allied forces gained victory over Japan, and the long war finally ended.

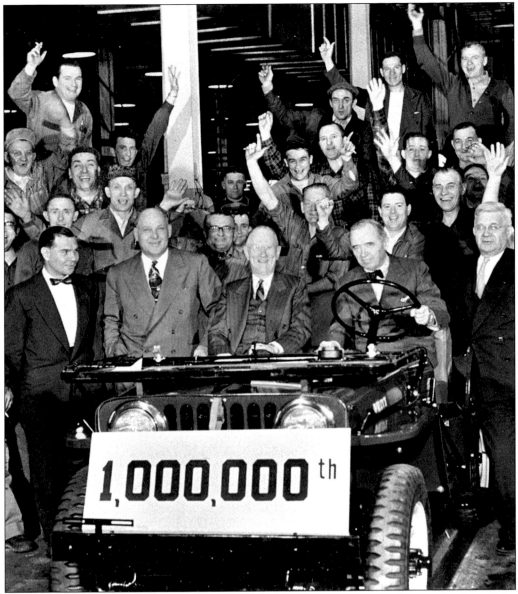

While the vehicle had to be modified after the war for the consumer market, production of the Jeep continued apace and soon one million had been built. Here, Ward Canaday sits in the passenger seat of the landmark millionth vehicle.

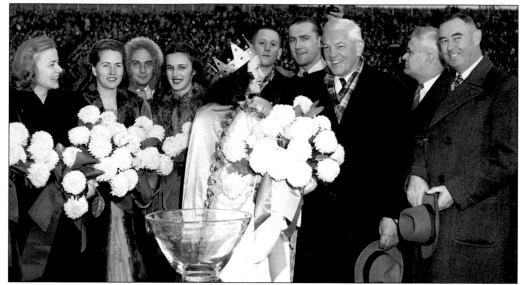

With nearly five years of pent-up consumer demand and troops returning home, the city adjusted to a post-war economy. Unemployment rose, and housing shortages were met through the erection of temporary housing from war surplus barracks. But many activities that had stopped because of the war returned, including football at the University of Toledo. In 1946, Wayne Kohn, an employee of Libbey-Owens-Ford, suggested renaming the football stadium the Glass Bowl to reflect Toledo's status as Glass Capital of the World. The renaming ceremony was attended by many, and Toledo defeated Bates College in the first game.

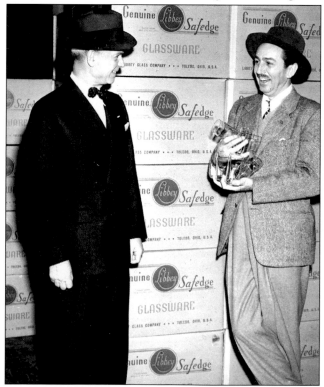

A post-war baby boom helped the economy recover quickly. Hollywood stars lent their names to consumer products like Libbey Glass. Here, John Wright (left), general manager of Libbey Glass, welcomes Walt Disney (right) in 1946.

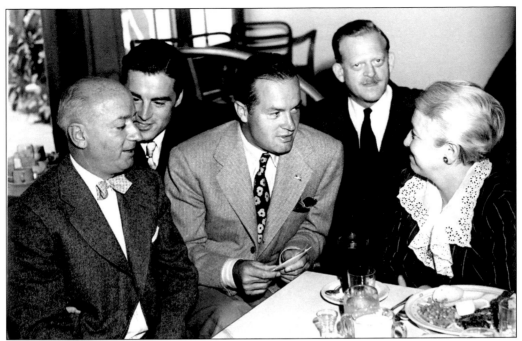

Bob Hope (middle) also visited Toledo and met with Randy Barnard (left), general factories manager at Owens-Illinois, and J. Preston Levis (right), president.

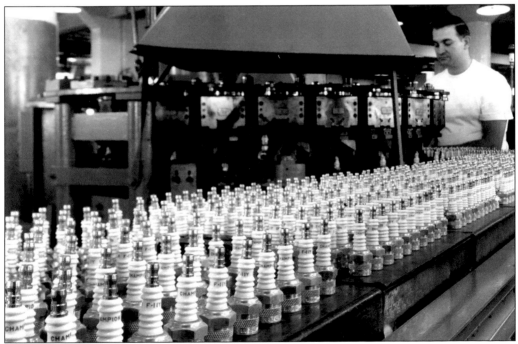

Post-war prosperity brought well-paying industrial jobs to the city. Here, a production worker watches over an unending line of Champion spark plugs. (Courtesy of the Toledo–Lucas County Public Library.)

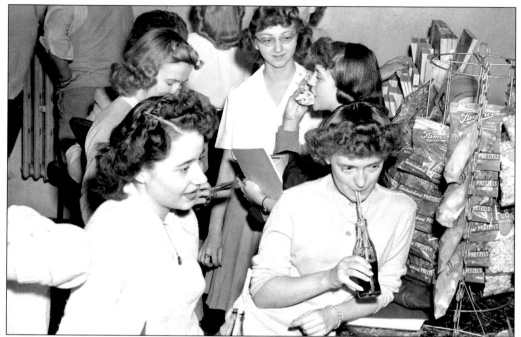

Life after the war reflected the national mood of conservatism, even among college students. Women who worked outside the home during the war returned to the traditional roles of housewives and mothers.

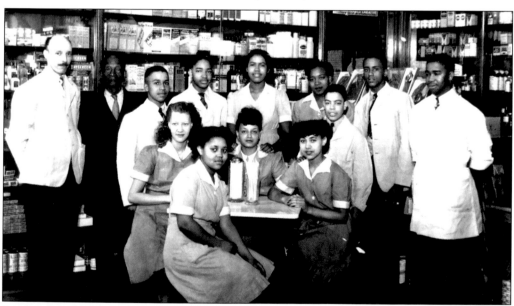

In the decade from 1940 to 1950, the number of non-whites living in Toledo increased by 10,000. Ella P. Stewart was one of the first African American women in the country to receive a degree in pharmacy. With her husband, she opened Stewart's Pharmacy on Indiana Avenue in the 1920s; it became the first to serve the city's African American community. This photograph shows Stewart's Pharmacy employees around 1950. (Courtesy of the Toledo–Lucas County Public Library.)

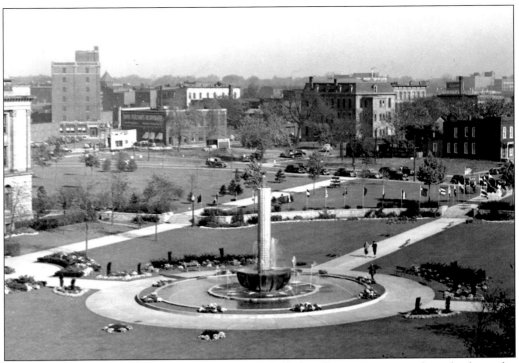

To honor the nearly 1,200 Lucas County residents killed in the war, a memorial was built on the civic center mall and dedicated on Memorial Day in 1948.

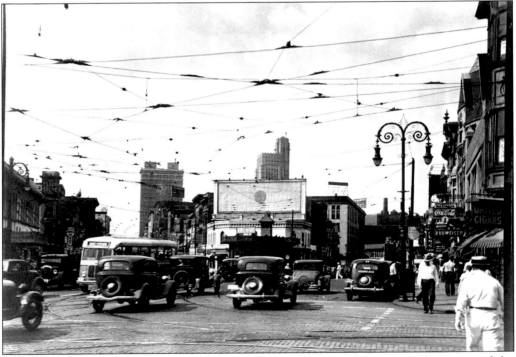

These crowded downtown streets demonstrate the prosperous post-war times. (Courtesy of the Toledo–Lucas County Public Library.)

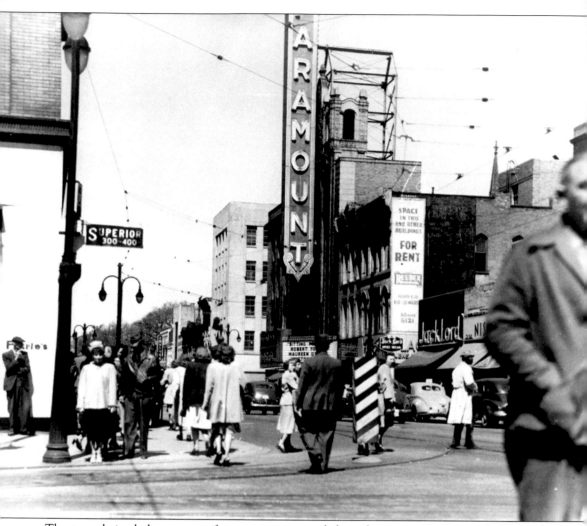

Theaters thrived downtown after many converted from live stages to movie houses. The Paramount, located at Adams and Huron Streets, was a grand movie palace playing all of the Hollywood blockbusters.

The baby boom fueled the post-war housing market. New neighborhoods were developed in areas outside of the downtown, aimed at middle-class income earners.

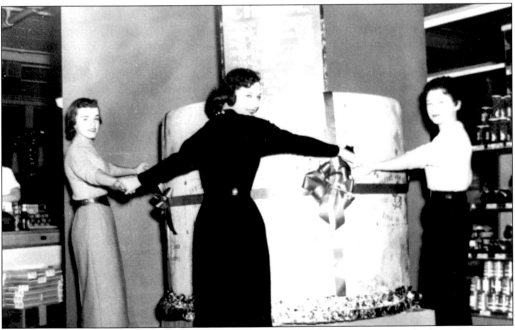

Post-war prosperity and pent-up demand fueled the market for consumer goods. One downtown department store—Tiedtke's—became a local institution. Each Christmas, the store promoted itself by bringing in a huge wheel of cheese, which was cut up and sold by the pound to eager buyers. (Courtesy of the Toledo–Lucas County Public Library.)

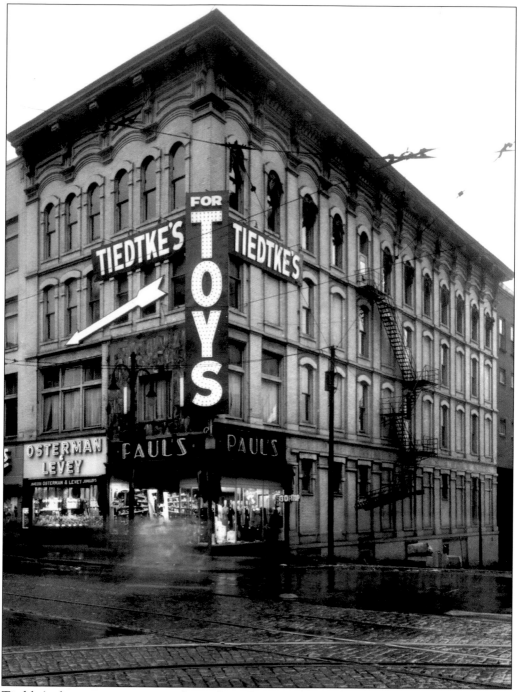

Tiedtke's department store was located on Summit Street. (Courtesy of the Toledo–Lucas County Public Library.)

# *Four*

# TOLEDO TOMORROW

As far back as 1868, when Jesup W. Scott proclaimed Toledo the "Future Great City of the World," the city has seen its share of planners, promoters, and prognosticators. The optimism of the post–World War II period launched yet another effort to plan for a great future on a grand scale. In 1945, Paul Block Jr., publisher of the *Toledo Blade*, hired designer Norman Bel Geddes and his associates to craft a model of what the city might look like in 1995. Geddes's model was displayed in an exhibit at the zoo called "Toledo Tomorrow."

Geddes originated from Adrian, Michigan. Prior to "Toledo Tomorrow," he was known for the "Futurama" exhibit at the 1939 New York World's Fair. His plan for Toledo earned him more national attention.

Geddes's exhibit urged Toledo to adopt a master plan that blended the city's unique geography with an improved quality of life for city residents. The haphazard transportation routes of the city were a particular concern, and Geddes focused most of his plan on this problem. Among his ideas was a new Union Terminal, which would combine a railroad station with an airport and bus terminal. Four additional airports were also part of Geddes's plan. Automobiles would travel on new highways around the city without traffic congestion. The Maumee River would be developed to combine both commercial and recreational uses. Housing developments would be built around cul-de-sacs to provide green spaces and create a greater sense of community.

Like other visions for Toledo's future developed by earlier dreamers, little of Geddes's vision actually became reality. A new Union Station *was* dedicated in 1950, but it did not include an adjacent airport or bus terminal. A new airport opened in 1954, but it was built miles outside the city in Swanton. A new highway system and turnpike were constructed, but rather than improve the city, they became a means to bypass the downtown, and in the end, these thoroughfares promoted suburbanization.

Ironically, rather than marking the dawn of a new era, "Toledo Tomorrow" coincided with a beginning of the downtown's decline. A new word entered the vocabulary of city leaders: revitalization. Urban renewal in the 1960s was the first effort at the rebirth of the downtown. Over the next 45 years, these redevelopment schemes—Riverview, Portside, Fort Industry Square, One SeaGate, One Government Center, the SeaGate Centre, the Erie Street Market, Fifth Third Field, the Docks, and most recently, the Marina District and the Edison Steam Plant—have all tried to be the silver bullet. While individually some have been successes, collectively they have largely failed to rescue the downtown. Today, not a single department

store is located downtown, and retail outlets of any kind are few. Parking continues to be seen as an obstacle to downtown success, despite the destruction of many architectural gems for parking lots. In the 1980s, the historic underpinnings of the city's economy crumbled as many of Toledo's Fortune 500 companies were bought up, broken apart, and sold as pieces in the boom years of corporate mergers. The trend away from the downtown continues as those few corporations left with headquarters in the central city threaten to move to greener pastures in the suburbs.

But Toledo cannot be defined by its downtown alone. Many of its neighborhoods remain strong, and some, like the Old West End, have gone through their own phases of revitalization. The cultural institutions with deep historical roots in the city thrive. The university has re-committed itself in recent years to an active role in the city's improvement. Still, in the 21st century, Toledo seems as far away from being the Future Great City of the World as it did in 1868, when Jesup Scott declared it as such. Sometime in the 1960s, Norman Bel Geddes's model for the "Toledo Tomorrow" exhibit was lost, and to this day has never been recovered, an ironic symbol of Toledo's lost future.

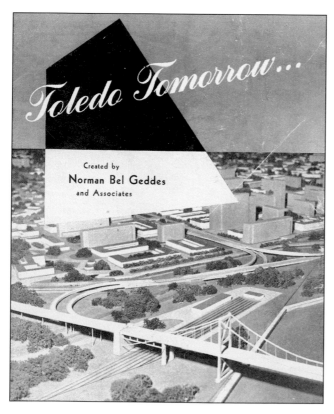

The exhibit "Toledo Tomorrow" opened in the natural history museum of the zoo on July 4, 1945. The exhibit was the brainchild of Toledo *Blade* publisher Paul Block Jr., who commissioned architect Norman Bel Geddes to design a model of Toledo in 1995.

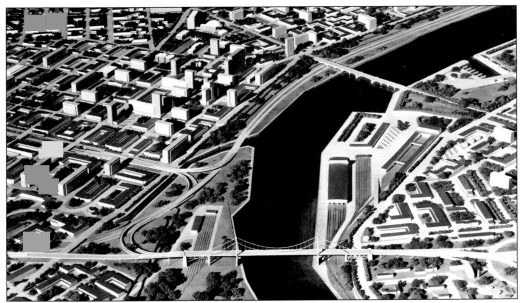

Norman Bel Geddes's exhibit was similar to the "Futurama" exhibit he prepared for the New York World's Fair in 1939. The Toledo model was 61 feet in length and cost an estimated $250,000. Geddes and his associates researched the city for 18 months, and the result was a master plan that laid out the broad brush strokes for the city's future development. The exhibit was dedicated in memory of those who died in the war, and "to the future happiness of those men and women who will return."

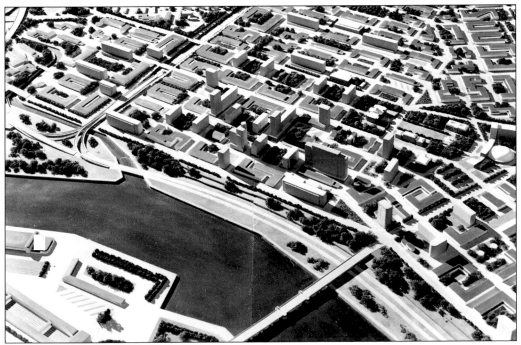

Among the recommendations of the plan were a terminal serving all types of transportation, a downtown passenger airport, "congestion-proof express highways," and beautification of the riverfront. Geddes's vision gained the city national attention.

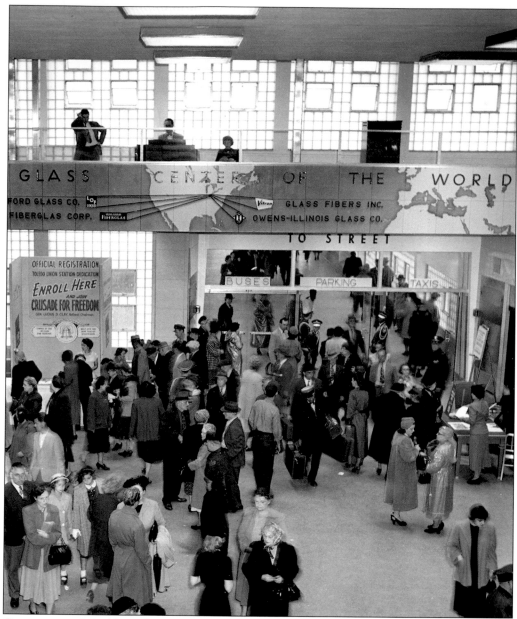

One impact of Geddes's plan was the construction of a new Union Station. The old railroad station, built in 1886, had been severely damaged by a fire in 1930. At that time, it was hoped the station would be demolished, but instead it was merely repaired. Finally, in 1950, a new terminal was built in a modern, sleek style. Dedication of the building took place on September 22, 1950. It did not, however, combine rail, air, and automobile transportation, as Geddes had suggested.

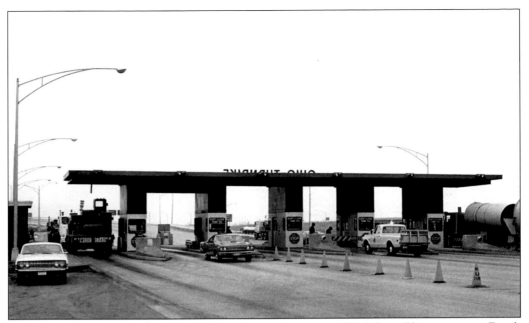

The most significant roadway project for the city began in 1949, when Ohio governor Frank Lausche created the Ohio Turnpike Commission to plan the state's participation in a nationwide highway connecting the east and west coasts. Despite protests from residents in Maumee about the route of the road, construction of the Ohio Turnpike started in 1952 and finished in 1955. (Courtesy of the Toledo–Lucas County Public Library.)

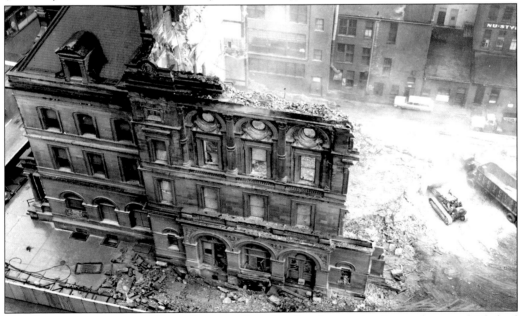

Rapidly increasing automobile traffic necessitated major changes in city roadways, which had been designed for horses, not cars. Many roads were widened to accommodate traffic. But some of the great architectural landmarks of the 19th century were demolished in order to build parking lots for cars downtown, or, in the case of the federal building, for urban renewal projects. (Courtesy of the Toledo–Lucas County Public Library.)

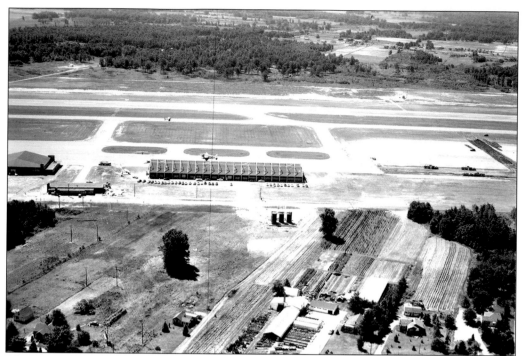

Also spurred on by the Geddes exhibit, the city and county began to plan for a new airport soon after the war ended, but the project stalled when the federal government withdrew its financial support. In 1952, six Toledo corporations purchased a 1,100-acre site near Swanton and agreed to sell the land at cost to the government. Voters approved the plan, and the new airport was dedicated on October 31, 1954.

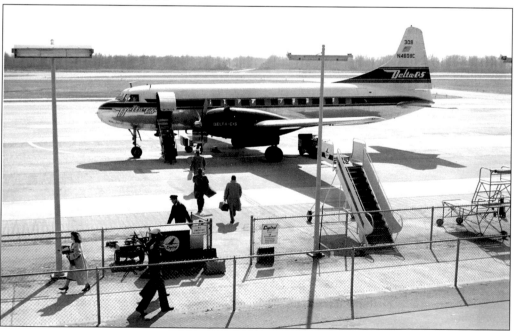

The post-war years saw commercial developments outside the central city. Shopping centers such as the Colony, the city's first, were built close to these new neighborhoods. (Courtesy of the Toledo–Lucas County Public Library.)

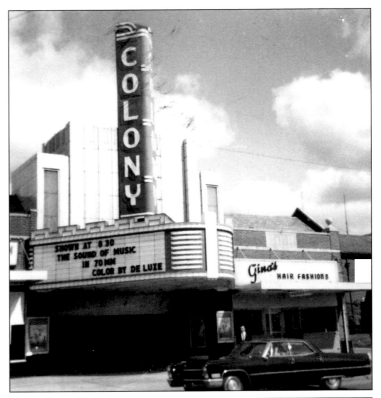

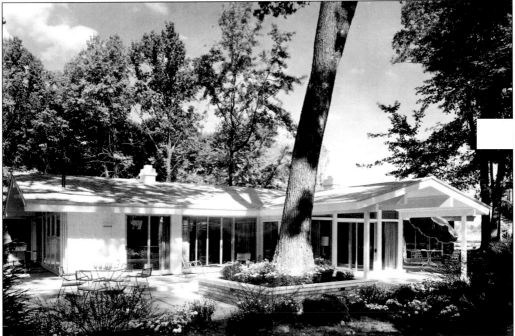

In the 1950s, Toledo's neighborhoods continued to expand to meet the housing needs of the baby boom. Lincolnshire was developed by the Scholz Construction Corporation in the mid-1950s. The homes were modern one-story ranch styles with large picture windows.

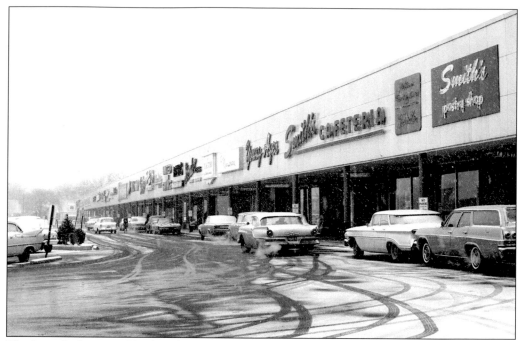

The Lincolnshire neighborhood was convenient to the new Westgate Shopping Center, which opened in 1957. Complexes like Westgate spelled the beginning of the end for downtown department stores.

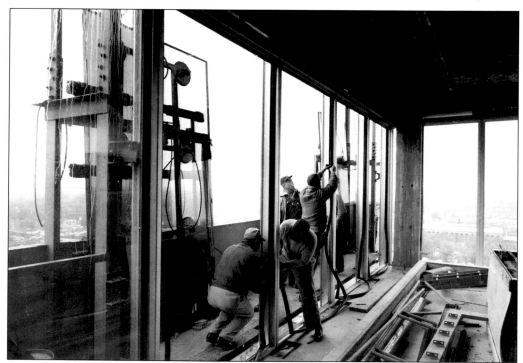

In 1958, Libbey-Owens-Ford began construction of a new downtown headquarters that would serve as a showcase for its major product: window glass.

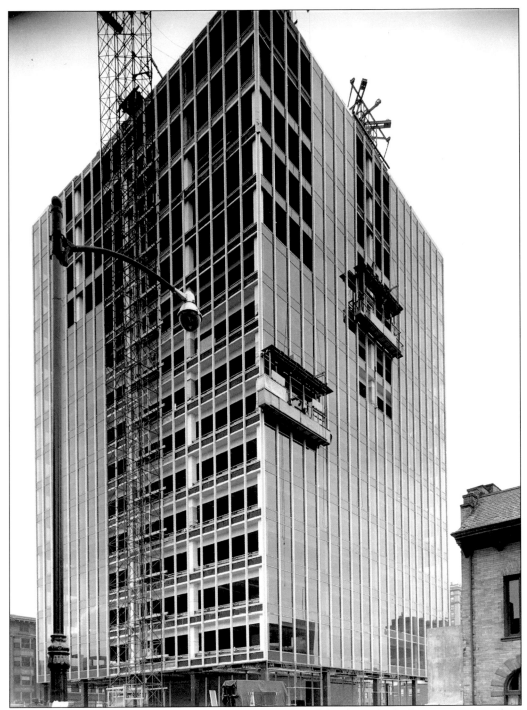

Libbey-Owens-Ford's development of strengthened glass (like that which the company used on its own headquarters, shown here) made possible sweeping glass skyscrapers in cities across the nation. One of the largest such buildings constructed with the company's glass was the World Trade Center in New York City.

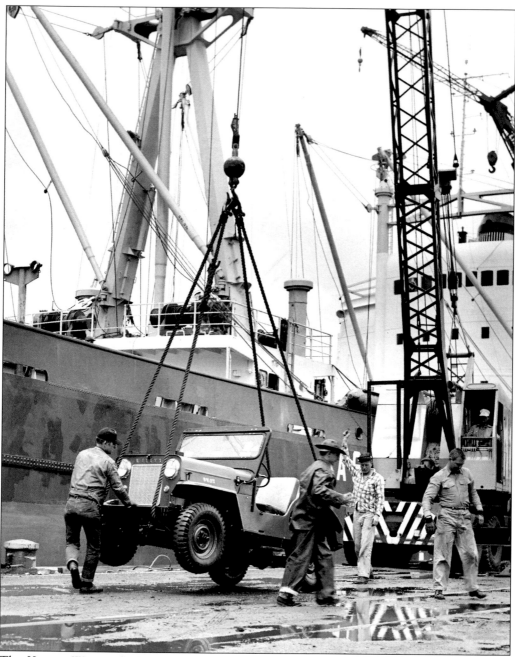

The Korean War sparked another boom for Toledo businesses that supplied products for the war. Willys-Overland's Jeep, which had proven its durability in World War II, was again called into war production. Here, Jeeps are loaded onto ships for transport to Korea. (Courtesy of the Toledo–Lucas County Public Library.)

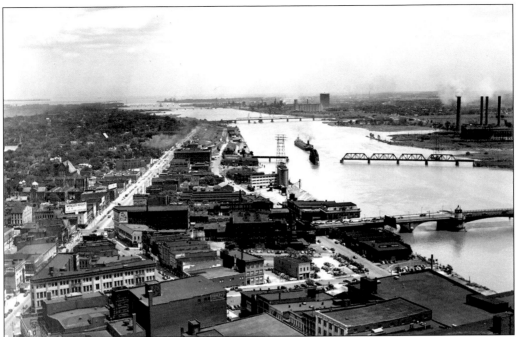

With the completion of the St. Lawrence Seaway in 1959, Toledo's importance as a Great Lakes port grew. In 1955, the Toledo Port Authority was created to take advantage of the city's location on the seaway.

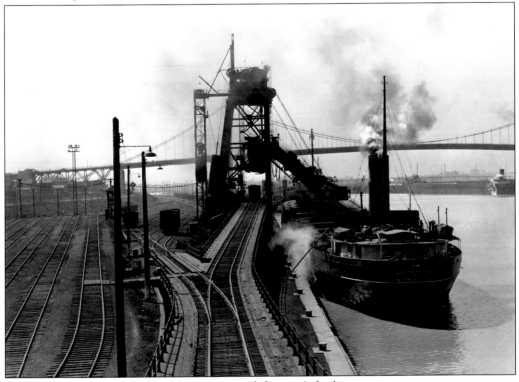

In 1959, voters approved a bond levy to expand the port's facilities.

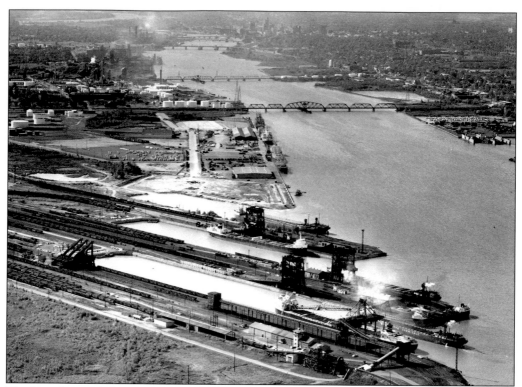

The busy Port Toledo is pictured here.

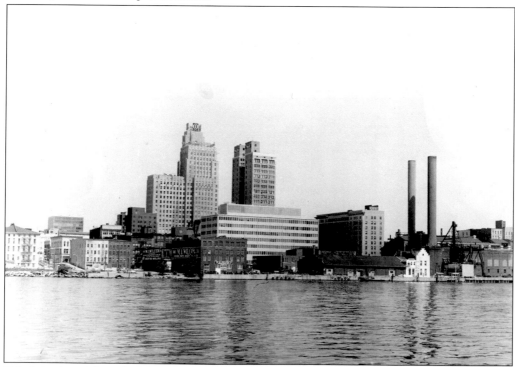

Toledo is viewed from the east side in 1964. (Courtesy of the Toledo–Lucas County Public Library.)

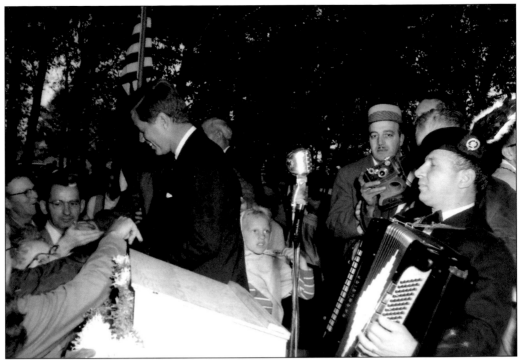

John F. Kennedy made a campaign stop in Toledo in 1960. (Courtesy of the Toledo–Lucas County Public Library.)

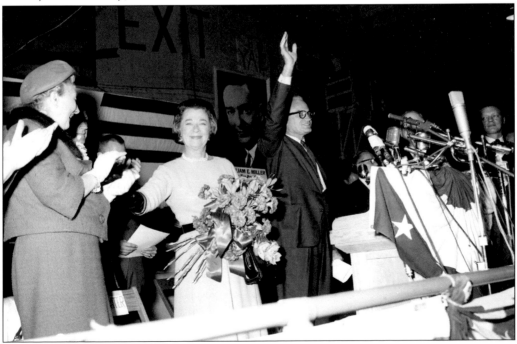

Barry Goldwater campaigned for the presidency in 1963 in the Field House at the University of Toledo. The event drew national publicity when supporters of Democrat Lyndon Johnson drowned out Goldwater, who was unable to continue his speech.

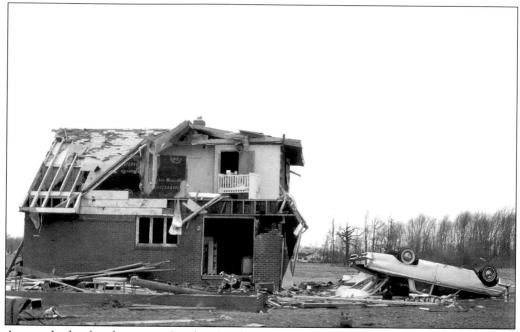

A tornado that hit the city on Sunday, April 11, 1965, killed 15 people and destroyed 310 homes on the city's north side. Particularly hard hit was Point Place. Damages totaled $12 million, and Pres. Lyndon Johnson declared the city a disaster area. (Courtesy of the Toledo–Lucas County Public Library.)

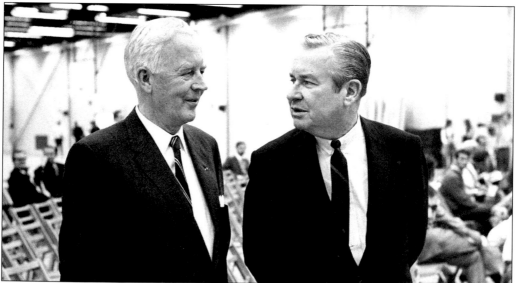

When founded in 1872, the Toledo University of Arts and Trades was a private institution. In 1884, the assets of the university were given to the city, and until 1967, the University of Toledo was a municipal institution supported by the taxpayers of the city. By the 1950s, however, the burden of supporting the university had become too expensive. Pres. William S. Carlson (left) led efforts for the university to become part of the state system, a feat achieved on July 1, 1967. Gov. James Rhodes (right) attended ceremonies to make the transition. The change allowed for rapid expansions of the campus environs and academic programs.

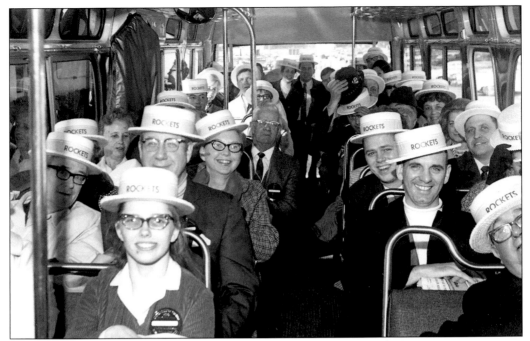

Between 1969 and 1972, the University of Toledo's football team scored 35 consecutive victories, the second longest winning streak in college football history. Here, fans anxiously make the bus trip to the Tangerine Bowl in 1969.

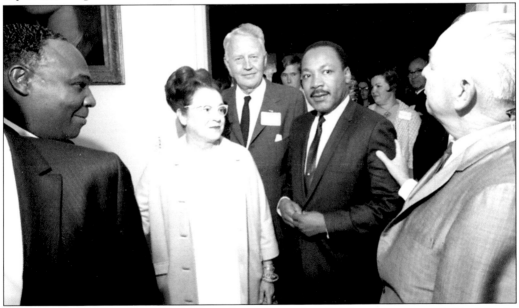

The 1960s brought a call to establish racial equality and civil rights, a movement led by Martin Luther King Jr. In his only Toledo appearance, Rev. King spoke to 3,500 people in the Scott High School field house. In his speech, King called non-violence "the most potent weapon" in the civil rights movement. Before his speech, King had attended a reception at the home of Edward Lamb (right) also attended by University of Toledo president William Carlson (on the left of King, center).

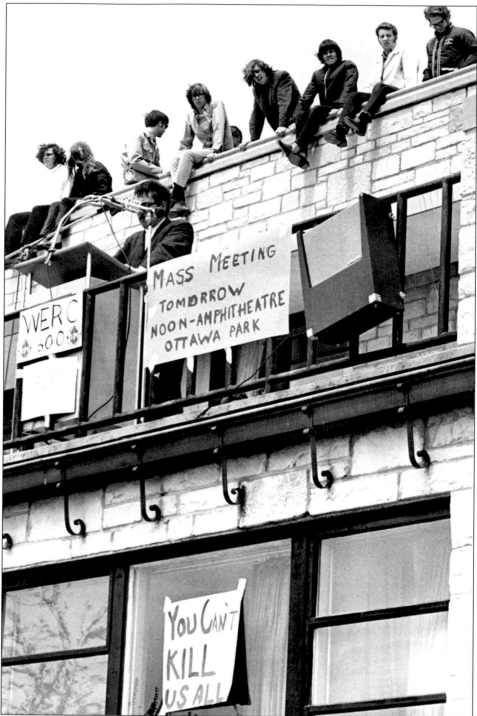

The decade also brought unrest to college campuses as students protested the United States involvement in Vietnam. After four students were killed by members of the Ohio National Guard at Kent State University on May 4, 1970, University of Toledo students held rallies and teach-ins to protest the action, and classes were cancelled.

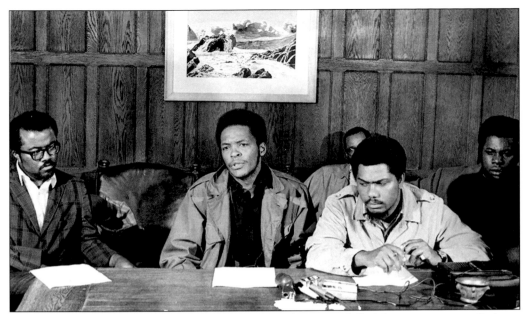

Less than two weeks later, two African American students were killed during a protest at Jackson State University in Mississippi. After this tragedy, the University of Toledo did little to mark the occasion. Black students protested this perceived indifference by blockading University Hall. Pres. William Carlson met with the leaders of the protest in his office, and the two sides reached an agreement to end the protest peacefully.

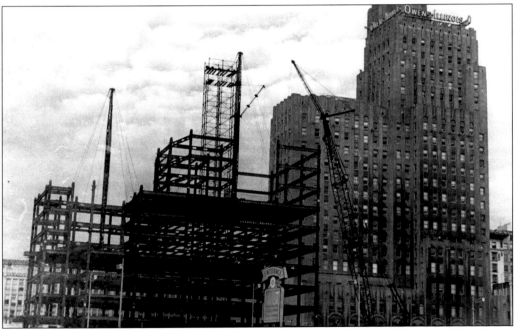

Downtown renewal began in the 1960s with a project called Riverview I. More than 20 buildings were torn down to make room for the new Toledo Edison headquarters and the Fiberglas Tower, the central office of Owens-Corning, completed in 1969. (Courtesy of the Toledo–Lucas County Public Library.)

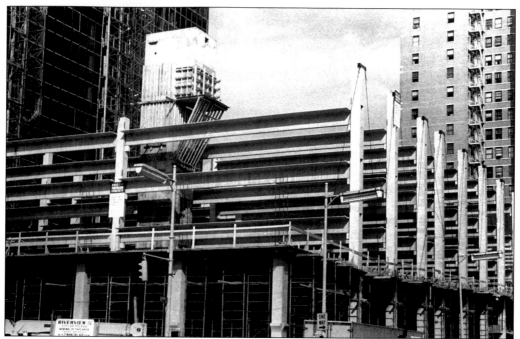

The Riverview project included a new parking structure adjacent to the Fiberglas Tower (under construction behind the garage). (Courtesy of the Toledo–Lucas County Public Library.)

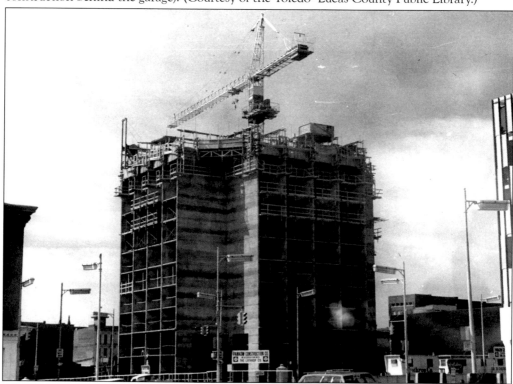

Also part of the Riverview development was a new Holiday Inn hotel. (Courtesy of the Toledo–Lucas County Public Library.)

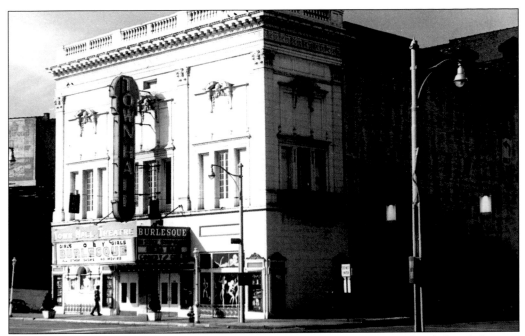

Burlesque became a victim of downtown revitalization and the desire of Toledo's fathers to improve the city's image. The Town Hall Theater, shown here, was purchased in 1958 by noted burlesque performer Rose LaRose, who tried hard to keep this form of entertainment alive in the city. (Courtesy of the Toledo–Lucas County Public Library.)

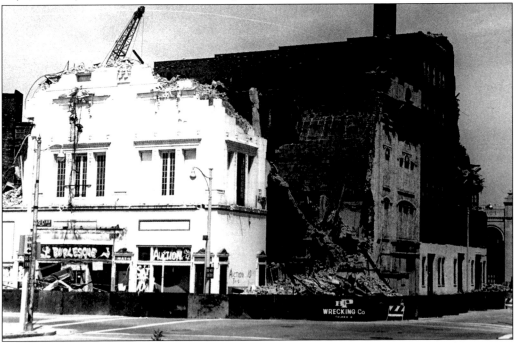

Unfortunately, the theater fell victim to re-development in 1963. LaRose then moved her act to the Esquire, but was unable to keep the theater going, ending Toledo's once lively burlesque scene that dated back to the days of vaudeville. (Courtesy of the Toledo–Lucas County Public Library.)

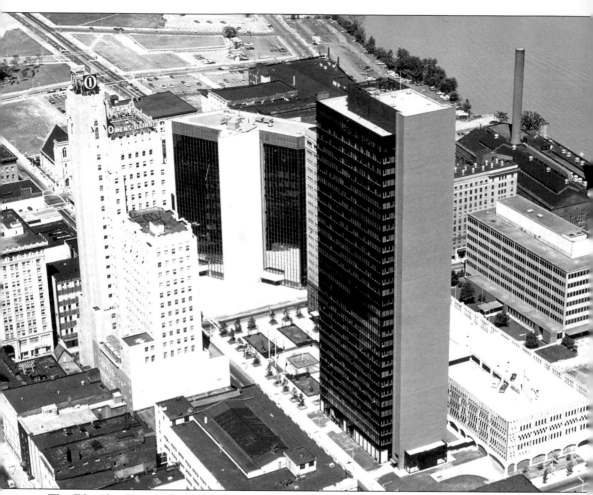

The Fiberglas Tower, the headquarters of Owens-Corning, stood directly across from Owens-Illinois, which had moved into the former Ohio Savings Bank building in 1931. The Fiberglas Tower featured a popular restaurant on the top floor.

The Riverview area included the Fiberglas Tower, Levis Square (seen here), and the Toledo Edison building.

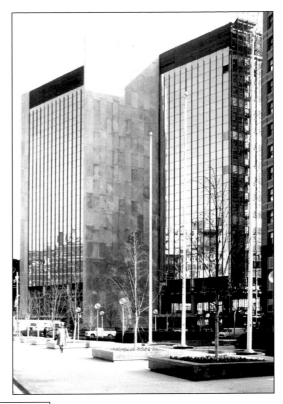

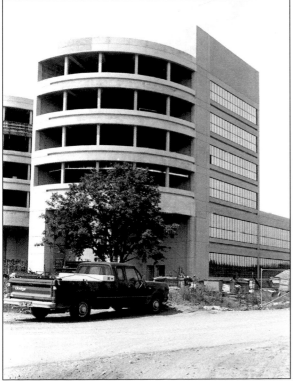

Fueled by greater access to healthcare because of the Great Society programs of the 1960s and the booming post-war population spurt, America struggled with a shortage of doctors in the 1960s. To meet the need, 40 new medical schools opened around the country between 1960 and 1980. In Ohio, local studies of doctor shortages propelled the state to plan for four new medical colleges, including the Medical College of Ohio. The college was originally intended as part of the University of Toledo, but was founded as an independent institution largely due to political pressure from *Blade* publisher Paul Block Jr.

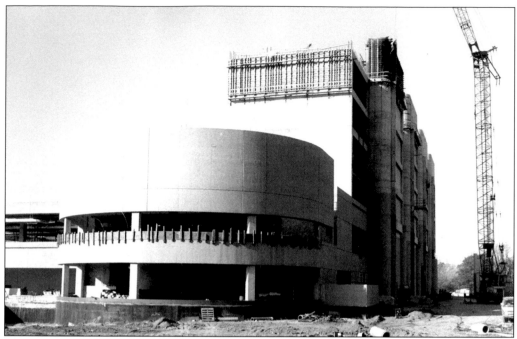

The new medical college campus was dedicated on September 21, 1969.

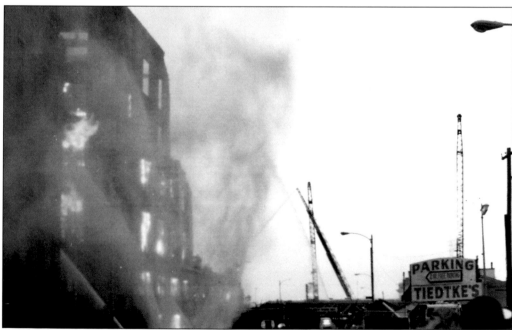

A spectacular fire destroyed Toledo's landmark Tiedtke's department store in 1975. The store had fallen on hard times with the decline in retail business downtown, closing its doors in 1972. The burned-out shell of the store was demolished, which opened up space for new development on the riverfront. (Courtesy of the Toledo–Lucas County Public Library.)

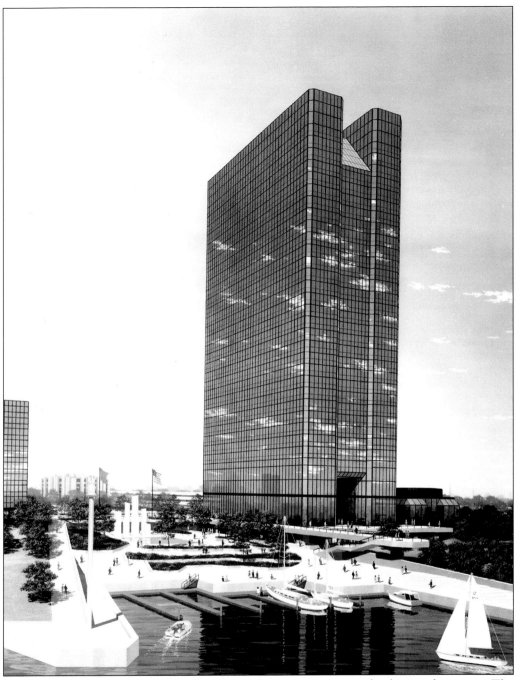

In 1977, a new master plan for the city proposed major renovations for the riverfront area. The plan included a new county-city-state office building, new headquarters for Toledo Trust and Owens-Illinois, a festival marketplace, and an upscale hotel. One SeaGate was the name given to the new Owens-Illinois building, pictured here.

Betty Mauk made her first trip to France in 1954 and fell in love with the country. In an effort to bring some of France to Toledo, she pushed for the creation of Promenade Park downtown in the 1970s. She opened a small stand in the park in 1972 to sell crepes, which the city later forced her to close. Mauk also purchased this French kiosk, which she placed at the park entrance to announce community events. Mauk's activism helped preserve the riverfront for all citizens of the city. (Courtesy of the Toledo–Lucas County Public Library.)

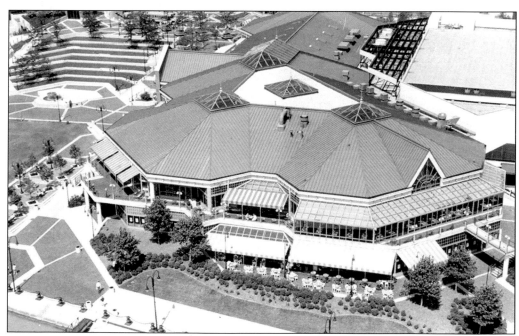

Ground was broken for Portside in December 1982. The development was built on the site of the old Tiedtke's and featured retail stores, entertainment, and restaurants. It was designed by James Rouse, who had also designed Baltimore's successful Harborplace.

While initially met with great excitement, Portside businesses could not sustain themselves, and the development closed in 1990. In 1997, the facility reopened as the Center of Science and Industry.

The television show M*A*S*H provided national publicity for Toledo when its native son, Jamie Farr, frequently used the series to talk about his hometown. Farr became a major promoter of the city, and his LPGA golf tournament continues to be a major draw. In 1983, the University of Toledo honored Farr with an honorary degree.

The university presented Rep. Marcy Kaptur with an honorary degree in 1993. Kaptur, first elected to Congress in 1982, has enjoyed the longest tenure of any woman in the House of Representatives.

In an effort to revitalize passenger train service, the Central Union terminal was refurbished in 1996.

# INDEX

# BIBLIOGRAPHY

Barclay, Morgan and Charles N. Glaab. *Toledo: Gateway to the Great Lakes*. Tulsa, OK: Continental Heritage Press, 1982.

Fairfield, E. William. *Fire and Sand: The History of the Libbey-Owens Sheet Glass Co.* Cleveland, OH: Lezius-Hiles, 1960.

Grigsby, John. Papers, 1892–2000, MSS-128. Ward M. Canaday Center for Special Collections, the University of Toledo.

Jackson, Joseph M. Photograph Collection, MSS-182. Ward M. Canaday Center for Special Collections, the University of Toledo.

Killits, John M., ed. *Toledo and Lucas County, Ohio, 1623–1923*. Chicago: S. J. Clarke Publishing, 1923.

Libbey-Owens-Ford Glass Company Records, MSS-066. Ward M. Canaday Center for Special Collections, the University of Toledo.

Ligibel, Ted. *The Toledo Zoo's First 100 Years: A Century of Adventure*. Virginia Beach, VA: Donning Company, 1999.

McMaster, Julie. *The Enduring Legacy: A Pictorial History of the Toledo Museum of Art*. Toledo, OH: Toledo Museum of Art, 2001.

Paquette, Jack. Collection on Northwest Ohio's Glass Industry, 1885–2003, MSS-169. Ward M. Canaday Center for Special Collections, the University of Toledo.

Porter, Tana Mosier. *Toledo Profile: A Sesquicentennial History*. Toledo, OH: Toledo Sesquicentennial Commission, 1987.

Speck, William D. *Toledo: A History in Architecture, 1914 to Century's End*. Chicago: Arcadia Publishing, 2003.

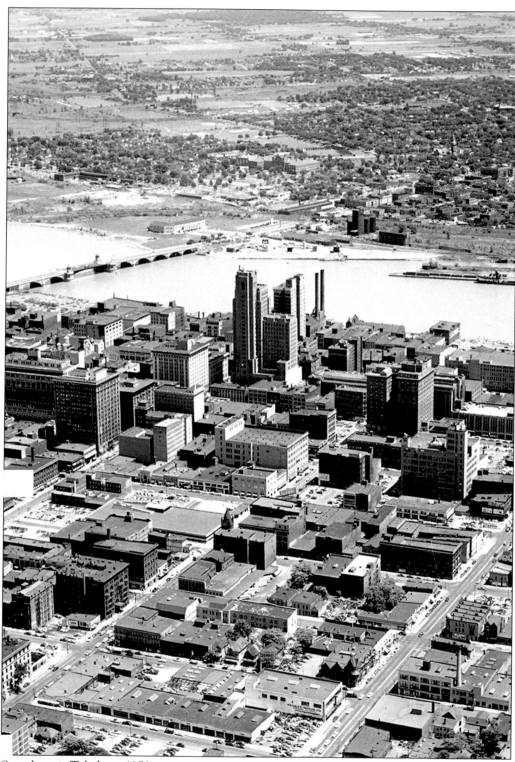

Seen here is Toledo, *c.* 1950.